REMEMBERING POSTMODERNISM

Trends in Recent Canadian Art

Mark A. Cheetham with Linda Hutcheon

RK
S

BAKER & TAYLOR BOOKS

Oxford University Press, 70 Wynford Drive, Don Mills, Ontario M3C 1J9

Toronto Oxford New York Delhi Bombay Calcutta Madras Karachi
Petaling Jaya Singapore Hong Kong Tokyo Nairobi Dar es Salaam
Cape Town Melbourne Auckland

and associated companies in
Berlin Ibadan

Canadian Cataloguing in Publication Data

Cheetham, Mark
Remembering postmodernism

Includes bibliographical references and index.
ISBN 0-19-540817-9

1. Postmodernism – Canada. 2. Art, Canadian.
3. Art, Modern – 20th century – Canada.
I. Hutcheon, Linda, 1947– . II. Title.

N6545.5.P66C48 1991 709'.71 C91-093126-7

Cover image: Joanne Tod, *Self-Portrait as Prostitute*.
Courtesy of Carman Lamanna Gallery, Toronto.

Designed by Heather Delfino

Printed in Canada by D.W. Friesen & Sons Ltd.

CONTENTS

ACKNOWLEDGEMENTS
v

PLATES
vii

PREFACE
ix

INTRODUCTION
1

REMEMBERING ART'S PAST
11

REMEMBERING THE SUBJECT
39

REMEMBERING SOCIETY
73

WORKS CITED AND CONSULTED
103

AFTERWORD
by Linda Hutcheon
Postmodernism's Ironic Paradoxes: Politics and Art
109

WORKS CITED
131

NOTES ON ARTISTS
135

INDEX
143

Dedicated to
the memory of

LAWRENCE ELLIOT HARVEY

ACKNOWLEDGEMENTS

This book is the result of over four years of inquiry and consultation, so naturally I have many people and institutions to thank for their encouragement and support. *Remembering Postmodernism* began with my research for an exhibition entitled *Memory Works*, which was initiated as a response to a challenge put by two visionary people, T.J. Collins, Vice-President Academic and Provost of the University of Western Ontario, and Nancy Poole, Executive Director of the London Regional Art and Historical Museums, both of whom saw the need for greater interaction between the University and the Gallery in London, Ontario. This original encouragement has been maintained by both institutions. I wish to thank the Canada Council and the Ontario Arts Council for enabling funds and the Faculty of Arts at Western for granting me a Research Professorship in 1989-90 to complete my text. Two research assistants at Western—Sonia Halpern and Anita Utas—helped with innumerable details. My thanks, too, to Marie Fleming, Paddy O'Brien, and especially Judith Rodger and Richard Teleky—my editor at Oxford University Press—for their enthusiasm and advice at crucial junctures.

I have learned a great deal from the artists whose works I discuss here. All have been generous with their time and ideas, and their collective excitement about this investigation of memory and the postmodern has often sustained me. My particular thanks go to Bruce Barber, Allyson Clay, and Joanne Tod. Linda Hutcheon's interest in and contribution to *Remembering Postmodernism* has been for me a tremendous source of pleasure and inspiration. Her knowledge of postmodern discourses is unequalled and her magnanimity in sharing her insights is a model for all scholars and critics. My sincere hope is that she will write more frequently on the contemporary visual arts in Canada.

This book is dedicated to the memory of Lawrence E. Harvey, my late father-in-law. In a bittersweet way, it is to his affliction with and death from Alzheimer's Disease that I trace my own interests in the workings of memory. But recollections of his keen intellect and unbounded zeal live on through Elizabeth D. Harvey, to whom I also dedicate this work in gratitude for the countless thoughts we have shared about memory.

PHOTOGRAPH CREDITS

1. Courtesy of Sheila Ayearst.
2. From The University of Lethbridge Art Gallery.
3. Art Gallery of Ontario, Toronto.
4. Courtesy of Greg Ludlow.
5. Mendel Art Gallery, Saskatoon, photograph by A.K. Photos, Saskatoon.
6. Art Gallery of Ontario, Toronto, Purchase, 1975.
7. Courtesy of Allyson Clay.
8. Courtesy of Joanne Tod. Photo by Peter MacCallum.
9. Courtesy of Carmen Lamanna Gallery.
10. Courtesy of Neil Wedman.
11. Photo by Ernest Mayer, The Winnipeg Art Gallery.
12. Photo courtesy Wyn C. Geleynse.
13. Collection of the Artist. Courtesy of the Wynick/Tuck Gallery, Toronto, Ontario: Photo by Cheryl O'Brien.
14. Courtesy of Alice Mansell.
15. Courtesy of Angela Grauerholz.
16. Courtesy of Sylvie Bélanger. Photo by Barrie Jones.
17. Courtesy of Vern Hume.
18. Private Collection. Courtesy of the Wynick/Tuck Gallery, Toronto, Ontario. Photo by Cheryl O'Brien.
19. Courtesy of Carmen Lamanna Gallery. Photo by Cheryl O'Brien.
20. National Gallery of Canada, Ottawa.
21. Courtesy of Jane Buyers. Photo by Tom Moore.
22. Courtesy of William MacDonnell.
23. Courtesy of Melvin Charney. © M. Charney.
24. National Gallery of Canada, Ottawa.
25. Courtesy of Bruce Barber.
26. Courtesy of Stan Denniston.
27 & 28. Courtesy of Geoff Miles.
29. Courtesy of Jane Corkin Gallery, Toronto.
30. Art Gallery of Ontario, Toronto. Gift from the Peggy Lownsbrough Fund, 1987. Used by permission of Canadian Artists' Representation Copyright Collective Inc.
31. Courtesy of the Carmen Lamanna Gallery. Photo by Peter MacCallum.

LIST OF PLATES

1. Sheila Ayearst, *Three Minutes* (1988; o/c, 5′ x 14′). Artist's coll'n.

2. General Idea, *The Unveiling of the Cornucopia: A Mural Fragment from the Room with the Unknown Function in the Villa dei Misteri of the 1984 Miss General Idea Pavilion* (1982; painted plasterboard, plywood, five 4′ x 8′ panels). University of Lethbridge.

3. Andy Fabo, *The Craft of the Contaminated* (1984; o/wood, 228.6 x 213.4 cm). Art Gallery of Ontario, Toronto.

4. Greg Ludlow, *All Conditions Are Temporary* (1984; paint, pastel, wood on panel, 243 x 396 cm). Artist's coll'n.

5. Joe Fafard, *Vincent* (1985; bronze, patina, oil; 99.7 x 68.5 x 19.2 cm). Mendel Art Gallery, Saskatoon.

6. Murray Favro, *Van Gogh's Room* (1973–74; mixed media with projection; 2.13 x 3.65 x 9.14 m). Art Gallery of Ontario, Toronto.

7. Allyson Clay, 'Eye to Eye', from *Lure* (1988; o/c, 4 x 13″ x 13″). Art Bank, Ottawa.

8. Joanne Tod, *Reds on Green* (1978; acrylic/canvas, 43″ x 51″). Artist's coll'n.

9. Joanne Tod, *Approximation* (1988; o/c, 7′ x 10′). Carmen Lamanna Gallery, Toronto.

10. Neil Wedman, *Death Ray* (1987; pastel/paper; 18 sections; total dimensions: 12′ x 24′). Artist's coll'n.

11. Marcel Gosselin, *The Observatory* (1986; mixed media sculpture, 190 x 30 x 30 cm). Artist's coll'n.

12. Wyn Gelynse, *Fear of Memory* (1990; mixed media installation). Brenda Wallace Gallery, Montréal.

13. Janice Gurney, *Screen* (1986; photostats, cibachromes, plexi; 38.5″ x 143″). Wynick Tuck Gallery, Toronto.

14. Alice Mansell, *Manoeuvre* (1986; o/c; 5′ x 7′). Artist's coll'n.

15. Angela Grauerholz, *Basel* (1986; b/w photo, 121 x 161 cm). Art 45, Montréal.

16. Sylvie Bélanger, one element from *Essai de Synthèse* (1990; 6 light boxes, 61 x 20 x 165 cm each, wood, slate, video). Artist's coll'n.

17. Vern Hume, *Lamented Moments/Desired Objects* (1988; video installation). Artist's coll'n.

18. Janice Gurney, *The Damage is Done* (1986; o/c, 49″ x 66″). Wynick Tuck Gallery, Toronto.

19. Robert Wiens, *The Rip* (1986; wood, glass, 75-watt lights, 1.2 x .9 x 1.8 m). Carmen Lamanna Gallery, Toronto.

20. Carl Beam, *The North American Iceberg* (1986; acrylic, photo silkscreen, and pencil on plexiglass, 213.6 x 374.1 cm). National Gallery, Ottawa.

21. Jane Buyers, *Language/Possession* (1987–88; mixed media: sculpture, 43.1 x 30.5 x 20.3 cm; drawings, 25.4 x 20.3 cm). Artist's coll'n.

22. William MacDonnell, *22 July 1968/16 Nov. 1885* (1986; lead, acrylic/canvas, 168 x 336 x 5 cm). Artist's coll'n.

23. Melvin Charney, *Les Maisons de la rue Sherbrooke* (1976; 16.4 x 15.8 x 12.0 m). Photo: Melvin Charney.

24. Barbara Steinman, *Cenotaph* (1985–86; mixed media). National Gallery, Ottawa.

25. Bruce Barber, *Nam II* (1990, mixed media). Artist's coll'n.

26. Stan Denniston, *Reminder #20* (1979; 2 silverprints, 42.5 x 100 cm). Artist's coll'n.

27. Geoff Miles, excerpt from *Foreign Relations* (1987; 2′ x 7′). Artist's coll'n.

28. Geoff Miles, excerpt from *The Trapper's Pleasure of the Text* (1985; 20″ x 24″). Artist's coll'n.

29. Nigel Scott, *Maillot Noir et Blanc (Julie Diving)* (1986). Jane Corkin Gallery, Toronto.

30. Carole Condé and Karl Beveridge, *No Immediate Threat* (1986; one of 10 cibachrome photographs, 50.0 x 29.5 cm each). Art Gallery of Ontario, Toronto.

31. Joanne Tod, *Self Portrait as Prostitute* (1983; acrylic/canvas, 59″ x 55″). Carmen Lamanna Gallery, Toronto.

PREFACE

Postmodernism in the Canadian visual arts is anything but monolithic, and I believe that it is best conceived through its dynamic attempts to evade traditional art-historical definition. For this reason, it is necessary to find a thematic focus for our understanding of the postmodern, instead of attempting to survey its manifestations or to claim to find its representative incarnations. In *Remembering Postmodernism*, I focus on the material and intellectual effects of memory in our recent visual culture as a way to articulate the complex of phenomena that we call postmodern. A culture's valuation of memory is in general a strong indication of its preoccupations and priorities, and a writer is very much a 'recollector', an agent for the reassembly of both works and ideas. It seems to me that there is a remarkable intersection in contemporary Canadian art between various thematics of memory and what I understand to be postmodernist impulses in artistic production. Four years of extensive research have helped to refine this rubric, but I remain convinced that these two admittedly daunting themes—memory and postmodernism in Canadian art—illuminate one another very effectively through their mutual delimitation. My arguments do not depend on a catalogue of supposedly postmodern phenomena—and in any case, postmodernism's signature memory itself undercuts any aspiration to a stable history.

Remembering Postmodernism attempts to mimic this sort of anti-foundational critique both in its structure and in its selection of works and artists. We have in the recent past been witnessing significantly new artistic deployments of memory in our culture, and these innovations can best be described as postmodern. I am well aware that 'postmodernism' is an unpopular term throughout the artistic community and with many scholars, but the fact remains that artists, curators, and critics all use variants on the word. As Fokkema puts it in a recent survey of the phenomenon, in our culture 'postmodernism is a *social fact*, a fact of shared or partly shared knowledge' (5). In short, however we determine its meaning, postmodernism exists, and it warrants serious attention. Again, my aim is to examine its manifestations through the lens of memory in order to make Canadian postmodernism, in its seminal visual incarnations, more comprehensible. Three interlocking chapters, then, inter-weave central themes of memory and the postmodern: the relation to art's history, the construction of the subject, and the social uses of memory.

The book thus has a double thematic edge, since the invocation of memory is crucial to what we should properly call various postmodernisms and *vice versa*. These two themes are also important independently, of course, so when I discuss memory (particularly because it is a topic neglected in current discourse on the arts, despite the fact that all art, artists, and critics depend on it) I will sometimes do so because of its inherent importance in art-making. My examination of postmodernism in Canadian art, on the other hand, will be limited largely to the mnemonic dimensions of these phenomena.

Working with two themes of this magnitude, I have had to be very selective in choosing which artists, works, and arguments to present. I take this to be a strength rather than a liability, however, since no overview of memory in art is really possible, and since a supposedly inclusive definition of postmodernism would be dysfunctional because it could not respond to the pace of change typical of its subject. This book does not attempt to present reified knowledge about either focal point, but rather to engage and to argue visually and verbally with the many issues that stem from bringing this wide range of artistic productions into new contexts in which they can work together in productive, if controversial, ways. I have chosen the artists and works with these ends in mind.

Without claiming to present an overview or a history, then, *Remembering Postmodernism* does address a large number of works and questions germane to an understanding of postmodernism in the Canadian visual arts. While many of the artists I discuss are 'important' in the sense that they have received wide recognition, each has been included because of the intersection of the thematics of memory and postmodernism in his or her work. Of course other artists could be discussed to advantage in this context, and I have mentioned some of them where appropriate. For the sake of detailed analysis and argumentation, however, I have sacrificed the consolations of an overview. The result is a non-traditional combination of works and individuals, but one that represents the extremely various inflections of geography, gender, and aesthetic ideology that typify the arts in this country. I also attempt to question the conventional conflation of artists' biographies with the meanings of their works; to deny any necessary connection between biography and meaning, without ignoring either co-ordinate, is itself a characteristic of postmodernism's challenge to received understandings of subjectivity. Those who want to know more about the artists discussed here are referred to the 'Notes on Artists' at the end of the book.

My three chapters address the imbrications of memory and postmodernism under the interdependent headings already suggested: 'Remem-

bering Art's Past', 'Remembering the Subject', and 'Remembering Society'. It would go against the grain of postmodern theory—with its close connections to poststructuralism—to claim originality for these groupings. In fact, the range of concepts that they make it possible to examine has, in important senses, already been written into our culture by the enormous number of discussions of postmodernism published in the past three decades. Put another way, even though this study is the first detailed examination of visual postmodernism in Canada, and the first to characterize memory as crucial to a discussion of postmodernism, it is also decidedly retrospective and recollective in relation to what we may now see as the thirty- (or so) year career of postmodernism. Again, this is an advantage, since although I would claim that postmodernism has flourished in Canada for as long as it has anywhere else, the appropriate time for theorizing about it, for memorializing its tendencies, is now, at the beginning of the 1990s (which may or may not lead us to speculate about the end of postmodernism). If postmodernism can be construed as memory work, our reflections have in many ways already been projected: this is perhaps the strongest rationale for the thematization of memory in my discussion of postmodernism. As Linda Hutcheon argues in *The Poetics of Postmodernism*, the postmodern predicament is to be complicit with the object of your critique. This applies equally to the artist and the critic, no matter how badly either one wishes to escape it, and it is my intention here both to re-collect, though not necessarily to affirm, what have become the predominant discourses of postmodernism, and to broach the possibility of a theoretical and practical revision of these norms by insisting on the largely unremarked roles of memory.

I will now examine in more detail the large topics inscribed in the three headings just outlined. The many issues attendant upon postmodernism's relations to the art-historical past are signalled by the habitual use of citation, quotation, and appropriation in current art practice. More specifically—and perhaps partly because of the notorious dissension entailed—postmodernism's built-in retrospective construction of modernisms against which it defines itself should be addressed in a Canadian context, which I hope to put into another frame—but not somehow to justify—through brief comparisons with international manifestations of postmodernism. These are the reference points of the first chapter, 'Remembering Art's Past'. Co-ordinates of this sort can be manipulated both specifically and generally, and I will move in both directions. In another attempt to undercut the conventional belief within art history that a survey of an artist's career gives an accurate history of his or her achievement, however, I will usually analyse individual works as a way of

understanding postmodernism more generally. My claim is that *neither* analytic procedure is neutral: what I hope to glean from my thematic focus and intensive reading is a new range of understandings of the mnemonic and the postmodern. In a very localized way and with these same ends in mind, I will also develop within this chapter three sub-themes: citation's workings in abstract art (where 'representation' can become crucially important), the gender implications of art-historical remembering, and— in part to avoid the often ponderous seriousness of discussions of postmodernism—the ludic, playful dimension of such references. On the level of general import, then, Chapter I queries current art's relation to and construal of history, a relation effected through memory.

In Chapter II, 'Remembering the Subject', I investigate the often self-conscious manipulation and construction of personal memories that go into a project of defining an elusive yet active 'subject' in works of art. These processes are inconceivable outside the axes of remembering and forgetting. By focusing on the mnemonic/artistic building of the 'subject', as opposed to what we would perhaps more naturally refer to as the 'self', I enter again into current debates, in this case about the status of subject-hood and the possibility and desirability of positing a stable point from which artistic creativity emanates. My large claim is that visual—that is to say (predominantly) non-verbal—memory, as it is deployed specifically in contemporary art, adds greatly to our understanding of the fabrication of the subject, an area of concern that I attempt to wrest from its traditional control by philosophy and psychology. On a more immediate plane, this chapter will extend the theme of the frequent playfulness as well as the important gender implications of the memory-postmodern intersection.

My final chapter depends on and interacts with my reflections on postmodern Canadian art's memories of the art-historical past and the subject, and is closely related to Linda Hutcheon's 'Afterword'. In 'Remembering Society', I examine works that assert the social and frequently political potentials of postmodern uses of memory. The ludic tends to drop away in this context (though not completely), while the issues of gender take on an even greater weight. Our construction, recollection, and—crucially—amnesia of history *through* the use of historical images provides a potent vehicle for critique. And to suggest that there is an 'our', a collective or even an individual agent for this critique, we must depend to some extent on memory's creation of a subject or agent, however provisional. It is proper that this topic should be the last in this three-chapter sequence since, in arguing implicitly that critique *should* be what art provides, these artists and works point to the future. In the most specific as well as the most sweeping terms, they demonstrate that this

future—like the past—can be projected only through memory, and that memory and its work are never neutral.

Linda Hutcheon's 'Afterword', a map of the complex territory of Canadian postmodernism drawn by the country's pre-eminent theorist on this topic, points in a corresponding direction. In 'Postmodernism's Ironic Paradoxes: Politics and Art', she not only draws us into these regions with consummate skill but also argues vigorously and persuasively for a politicized understanding of postmodernist theory and practice. Hutcheon's view in this essay is broader than that of the first three chapters and situates my specific discussions within the ongoing debates about postmodernism in Canada and internationally.

Many aspects of this book consciously engage with and attempt to counter received opinion, the 'party line' on individual art objects and their creators, on postmodernism, and on memory. Two choices have made this interaction possible and, I believe, desirable. First, the recollective and thematic nature of *Remembering Postmodernism* provides an opportunity to work as postmodern memory itself works, selectively and with what might be called theoretical purpose. This is very different from the well-worn notion of the 'benefit of hindsight', which relies on the assumption that there are stable historical objects to be seen and archaeologically displayed. This book argues that recollection is always re-creation based—paradoxically—on hopes for the future rather than on any reified past. Second, as academics, Linda Hutcheon and I are, as she puts it, 'ex-centrics' with relation to the art world. We are marginal to its centres. Hutcheon has also claimed, however, that 'thanks to the ex-centric, both postmodern theory and art have managed to break down the barrier between academic discourse and contemporary art (which is often marginalized, not to say ignored, in the academy)' (*Poetics*, 71). In keeping with this spirit, *Remembering Postmodernism* does not seek to pronounce upon but rather to keep open issues like the modern–postmodern relation, the role memory has in forging the subject, and the social and political effects of work based in memory.

INTRODUCTION

'To articulate the past historically does not mean to recognize it
'the way it really was'. . . . It means to seize hold of a memory
as it flashes up at a moment of danger.'
Walter Benjamin, 'Theses on the Philosophy of History', VI, 255

'We are confined to ways of describing whatever is described.
Our universe . . . consists of these ways rather than of
a world or of worlds.'
Nelson Goodman, *Ways of Worldmaking*, 2-3

Artists are the mnemonists of culture. Their work is memory work, both personal and social, both intellectual and material. I want to introduce the complexity of this thematics of memory and the ways in which I will discuss it in the chapters that follow with two arresting images, the Toronto painter Sheila Ayearst's *Three Minutes* (1988; Plate 1) and *The Unveiling of the Cornucopia: A Mural Fragment from the Room with the Unknown Function in the Villa dei Misteri of the 1984 Miss General Idea Pavilion* by General Idea (1982; Plate 2).

The left side of Ayearst's diptych reproduces in painstaking detail, and with close attention to seventeenth-century techniques of glazing, Rembrandt's fragmentary *Anatomy Lesson of Dr Joan Deijman* of 1656, now in the Rijksmuseum, Amsterdam. Appended and yet opposed to this visual, art-historical recollection are two memorial texts, one inside the other. The larger, apparently machine-produced text records with the

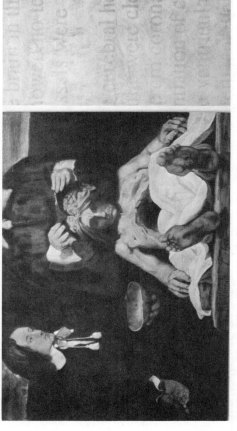

1 Sheila Ayearst,
Three Minutes (1988)

technical, scientific precision of medical terminology the results of an autopsy. Embedded in a cup-like form within this account is a smaller, much more personal and emotional homage to the death of a brain: 'The brain did not die at once. It took those three minutes'—an account that, as we will see, is not Ayearst's, but from which she derives her title. Both texts float on an indistinct surface that is visually reminiscent of the texture of brain tissue.

Even this initial description of *Three Minutes* reveals the complex layering of Ayearst's memory work. She has recalled an image from art's history that graphically displays the scientific dismemberment of a cadaver as well as textual references to two other deaths. The brain—the seat of memory, as we commonly think—is pictured in all three instances. Yet Ayearst's vision demands that we reconsider this habitual 'mentalist' understanding of memory's location, and indeed our resulting relations with the human beings who are defined by it. Her version of Rembrandt's painting is not as exact as it might appear: she has accentuated the exposed and excavated body cavity of the dead man, making this space as important both optically and thematically as the brain displayed by the surgeon. She remembers both body and brain—those elements that the Cartesian science evoked by Rembrandt literally takes apart—and considers the two somatically equal in their ability to remember, to record traces. On the right side of her work, one putatively objective medical appropriation of the brain and its memory similarily vies with the other text, a text that is also written by a doctor of our time and yet is contained in the 'same' skull cap held by the assistant in 'Rembrandt's' image. Crucially, this small text is inscribed in the *body* of the larger text. Ayearst's mnemonic devices thus tie the two sides of her piece together; visually, textually, and metaphorically, they tether the seventeenth century's science to that performed in the present while simultaneously offering subversive alternatives to both practices.

The rich intricacies of Ayearst's commentaries on memory, the brain, and science are made possible by memory, but not simply her memory. She relies on Rembrandt's more traditional reflection on Mantegna's *Dead Christ* (*c*. 1480), for example, and of the anatomy lessons he witnessed—as well as the doctors' recollections she quotes—and she also depends on her *viewer's* memories, which might extend from recognitions of art-historical allusions to reminiscences of personal experiences of death to the nature of medical experimentation and documentation in our society. What Ayearst initiates—but cannot and does not wish to control strictly—with her evocative image and texts is thus neither simply personal nor completely historical. Her work suggests the overlapping, mutually defining rela-

tionship between our everyday notion of memory as individual and history as somehow collective and objective, History with a capital H. In redefining memory and history in terms of one another, she makes material what Wittgenstein has called a 'memory–reaction' (343), and this reaction or set of reactions animates both her recollections and those of her viewers in the present.

With *The Unveiling of the Cornucopia*, the artists of General Idea invite 'the public to participate in the archaeology of memory' (40).[1] We see an ersatz ancient mural complete with all the proper art-historical and archaeological signs of its antiquity: faded colour, often imprecise details, visible traces of damage, and, above all, fragmentation. The central scene, however, is sufficiently intact to arouse our curiosity and to encourage attempts at reconstruction. Three anthropomorphic poodles seem to be performing some sort of mystery rite around a form that the title suggests is a cornucopia. The subtitle of this work alerts us to the artists' art-historical allusion to the famous Dionysiac mystery cult imaged on the walls of the Villa of Mysteries at Pompeii *c.* 50 BC. But this quotation—like Ayearst's—is only the beginning of a mnemonic reconstitution of meaning. In a catalogue text entitled *Cornucopia* accompanying their 1984 retrospective (itself a 'retrospective' event that was projected in much of their earlier work) the artists of General Idea illuminate a project that uncovers the role of memory in their art and in postmodernism generally, a project that *begins* (not ends, as in much current art-historical identification or appropriation) with our recognition of their allusion:

> The amorphous world of meanings and functions has traditionally been articulated through the architectural act of construction. But the three artists of General Idea have re-introduced *de*struction into the architectural process. In their long-term project, the 1984 Miss General Idea Pavilion, ruins are created as quickly as rooms are built. Accumulated layers of function and meaning slip in and out of focus, creating a shifting constellation of images which is the Pavilion itself. (67)

Traditional archaeology is based on the assumption that a stable past, *a* History, can be recovered, but General Idea mocks this possibility and the desire behind it by literalizing the 'shifting' nature of meaning. What *The Unveiling of the Cornucopia* uncovers is General Idea's self-created and well-marketed past, a past that here passes for antiquity by deploying culturally specific signs of history: fragmentation and damage. All the elements in this large mural were indeed pre-constructed precisely to allow for their partial destruction, their cultural weathering, which in turn permits them to *signify* pastness in an art-historical framework even though they are not

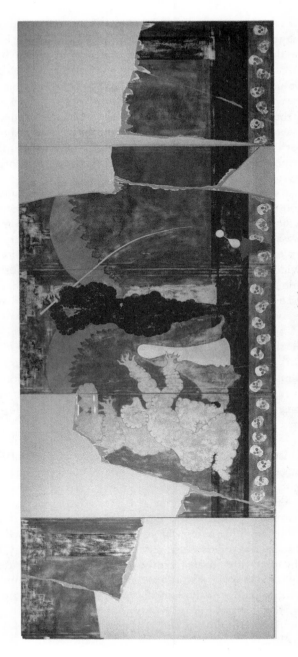

2 General Idea,
The Unveiling of the Cornucopia (1982)

literally old. We see General Idea's signature poodles, their famous zig-gurat forms, the cocktail glass spilling its cultural meanings to the left of the central poodle, and of course the cornucopia itself, which never reveals more than the perpetually plentiful process of construction/ destruction through which memory creates meaning. This image plays in a very telling way with its supposed antecedent at Pompeii: are we not encouraged by the transformation of the Roman wall painting's suppos-edly Dionysian women into poodles to question the self-serious assigning of meaning that typifies art history's own appropriation of this and all other 'past' images? The ludic frequently proclaims memory's work, as we will see throughout this book.

I suggested at the outset that *Three Minutes* and *The Unveiling of the Cornucopia* introduce the central dimensions of memory that I will explore and through which I will elaborate a theory of postmodernism in recent Canadian art. With the above descriptions in mind, let me specify this promise. Both works quote from the history of Western art, and this sort of citation is widely held to typify postmodernist practice. Against the now-fashionable lament—best articulated by Fredric Jameson—that this purportedly fast and loose play with art's history is nothing more than an empty pastiche, symptomatic of a contemporary loss of historical aware-ness, however, I want to argue that, in many more instances than those in which Jameson and followers like Terry Eagleton can justify their claims (and both authors can be criticized for the abstractness of their arguments, for their unwillingness to offer examples), art-historical recollections are in fact integral to a new concern for the status of history and the past in art. In 'Postmodernism, or the Cultural Logic of Late Capitalism' (1984)—an article that has rightly become a touchstone in discussions of postmodernism—Jameson bemoans what he sees as postmodernism's 'weakening of historicity, both in our relationship to public History and in the new forms of our private temporality' (58). This loss of the public and personal past, he claims, restricts an individual's 'capacity actively to extend its pro-tensions and re-tensions across the temporal manifold' (71)—in other words, his or her ability to understand the past and to act in a future extending from it. Jameson's ultimate regret, then, is for what he sees as a loss of social and political efficacy based on a loss of history. 'It is unsurprising', he has written more recently, in a tone that many critics of the postmodern have adopted without any attention to its local applica-bility, '. . . that most of the postmodernisms will betray the extinction of even the protopolitical in their agreeable ironies and their aesthetic cyni-cisms, their forced accommodation to the system' ('Postmodernism and Utopia', 13).

Jameson deploys his arguments about the loss of history in exactly the three areas in which I focalize memory: art's past (his claims about pastiche), the recollective construction of the subject (which for Jameson has lost its sense of past or future time), and social and political recall (where Jameson sees only a cynical quietism). My counter-claim is that postmodern memory as exemplified by Ayearst, General Idea, and the other artists and pieces in this book can effectively call into question the existence of the 'Real History' ('Cultural Logic', 68) on which all of Jameson's arguments covertly depend and for which he is nostalgic in spite of himself. Memory, with its evanescent yet specific inflections of meaning, *is* history in a postmodern culture. As we have seen, in these examples it is not possible to envision a Rembrandt painting, seventeenth-century medical practices, or Roman mystery cults except through the mediating lens of memory. This is not to suggest that the past doesn't exist, but rather to specify the *mode* of its existence, the nature of its 'reality'. Since by definition 'no statement about the past can be confirmed by examining the supposed facts' (Lowenthal, 187), history cannot exist apart from its viewers and their specific and ever-changing perspectives. The radical implication is that '*nothing* is natural about our memories, that the past . . . is an artifice' (Terdiman, 19) erected and mediated by the interests of the present. If we are tempted to defend Jameson by claiming a physical work of art—its status as physical object—as an irrefragable piece of history, an archaeological reminder, we need only think of how *The Unveiling of the Cornucopia* or *Three Minutes* augments the possible meanings of its art-historical referents, how each work *changes* the nature of its antecedent. Art-historical citation, then, can move beyond the superficial pastiche described by Jameson to a profound, though sometimes simultaneously playful, engagement with the notions of pastness and history in general. Memory *works*; it is effective, not cynical.

Three Minutes in particular counters Jameson's notion that 'private temporality', in the sense of personal history or the definition through time of what we call a subject or person, is lost in recent art. What we often see is just the opposite, an extension of this sense of history—sometimes (as in this instance) through a recollection of art, but also in other memories of past events—into the realm of the subject. Ayearst has brought seventeenth-century experimental science (in what could be argued to be its masculinist invasiveness) into a contemporary perspective precisely by linking Rembrandt's image with recent medical texts. We are thus asked to contemplate how the subject is construed today, and specifically how memory, mental and/or corporeal, is part of the definition of subjecthood. This latter consideration is at once personal and social, since *Three Minutes*

argues for a more inclusive and compassionate construction of the subject than that imaged by Ayearst's Rembrandt. And if we construe the political very inclusively as that realm of (unequal) power relations among members of society, then Ayearst's memories, in collaboration with those of her viewers, also act politically. Art-historical citation, for example—as I will argue throughout this book—is never gender-neutral. It is important politically that Ayearst, a woman, cites a male artist's privileged exposure of the seat of identity in memory and his mirroring of the intrusions of science. Ayearst stands back from this invasion precisely by quoting it, and she is thus able to insinuate an implicit critique of these cerebral and arguably masculinist practices by embodying the more compassionate small text about the brain's death. Her political move does not allow *our* memories to die. She accomplishes this not insignificant critique through painting—itself a masculine tradition—and by remembering in painting a male artist's and male physicians' work. But is this accomplishment in fact Jameson's 'forced accommodation to the system', or is it (as I would argue in concert with Linda Hutcheon in her 'Afterword'), an inevitable participation in that which one wants to criticize, the 'complicity' of postmodern critique? As Hutcheon shows, 'you cannot step outside that which you contest' (*Poetics*, 223). But if one cannot find static points of 'real' history against which to measure the present, it does not follow that critique becomes impossible or cynical, as Jameson claims. On the contrary, and as this discussion of postmodern recollection will show, it is his accusation that postmodernism is mere pastiche that is the easy and cynical criticism of surface appearances.

Before turning to other works to investigate further memory's crucial workings, I want to discuss briefly memory's essential correlate—*forgetting*—as it pertains to postmodern practice in the visual arts. A fuller consideration of Ayearst's works is a fitting vehicle for this discussion, since as I have argued with reference to *Three Minutes*, her mnemic practice precisely counters the notion of nostalgia for a real, authoritative history by engaging with the kinetics of remembering and forgetting.

For over a decade, Ayearst's paintings have been informed by an art-historical referencing or memory that goes far beyond pastiche. Her inspirations range from European 'masters' (three figures from Piero della Francesca's *Flagellation of Christ* [*c.* 1450] in *Sensible Passage*, 1983; the background landscape from Giorgione's *Tempest* in *Approaching Giorgione*, 1983) to Canadian favourites, like Ozias LeDuc's *Fin de Jour* in her own 1987 painting of the same name. None of her quotations are straight, however: as we see in *Three Minutes*, the critique she always offers relies on recontextualization—on remembering, and equally on forgetting, on

editing out crucial details. Her *Living On the Edge* (1986), for example, sets up a gender issue that we could refer to as the status of 'women's work'. On one side, she has painstakingly reproduced an image by the French eighteenth-century painter Fragonard of the famous falls at Tivoli, outside Rome. The date of the Fragonard is about 1760, and his emphasis on the women's happiness is a paradigm of the hegemonic cheerfulness of eighteenth-century view-painting in Italy. To this memory of the tradition, however, Ayearst has opposed a scene of contemporary 'leisure', or more precisely, male leisure, a scene that has been captured in memory by a photograph. The eighteenth-century has been 'forgotten'. Instead, the woman who looks towards us is quite clearly 'on the edge' psychologically, as opposed to the staffage figures in Fragonard's work, who seem to enjoy their vertiginous perch above the falls. Unlike these figures, the woman gazing out at us is highly personalized. In conversation, Ayearst has said that the woman is experiencing 'threat in suburbia', and I would speculate that her implied memory of the scene we see behind her is more corporeal than any notion of citation could ever capture.

The theme of threat or danger existing in our everyday lives appears again in a more recent work, *There is No Safety* (1989). This triptych of large photographs reports visually, and with a running text taken from a newspaper account, on a murder in an Oakville, Ontario, parking lot. In front of the central image of the site sits a version of Goya's *Colossus*, which Ayearst has painted over the photograph. This monster of Goya's imagination startles us with its anachronism and its fine-art look. But Ayearst's work suggests that this image of horror is neither extreme nor out of place today. What is perhaps even more distressing, Goya's image is itself reminiscent of the nineteenth-century notion of the pleasure of the sublime, which arises in the simultaneous experience of fear and one's safety from the danger perceived. The seemingly neutral reportage that Ayearst offers—text and photos—is itself voyeuristic in this way: we want the tragic events repeated for us mnemonically. This is the sublime enjoyment that Ayearst's allusions expose.

Just as one can claim that the production and reception of art are inconceivable without remembering, so too all art is a function of forgetting, of *selection*. The artist's creative decisions—conscious and unwitting alike—and the viewer's fabrication of meanings for the resulting work cannot obtain without this process of inclusion and exclusion. This may seem obvious enough, but when aesthetic memory is combined with a notion of 'real history' as in Jameson, art's inevitable and functional amnesia becomes problematic in the face of the desire and claim to know 'what really happened'. Western receivers of art, 'the privileged classes of

First World society,' he holds, 'run the risk of forgetting their memory' because of the commodification system of 'full postmodernist late capitalism with its perpetual present and its multiple historical amnesias' ('Postmodernism and Utopia', 14, 24). This view assumes that there was a period and a practice *without* multiple amnesias, a time when history was seen purely (the early twentieth-century avant-garde is Jameson's usual favourite for this honour). Looking at the mnemonics of recent art, however, suggests that such a time and place did not and could not exist. History as a communally shared past cannot exist without memory, and memory cannot function without the selectivity allowed by forgetting. The issue is not whether or not aspects of the past are remembered or forgotten, but rather *which* aspects are retained or erased, by whom, and for what ends. It is in these questions that we engage with the politics of memory and of postmodernism.

NOTES

[1]This passage refers to another work—*Toronto's Fault*—but can apply equally to the *Unveiling*.

I. REMEMBERING ART'S PAST

'[One] learns the concept of the past by remembering.'
Wittgenstein, *Philosophical Investigations*, 231

'One of the schools of Tlön . . . reasons that the present is
indefinite, that the future has no reality other than as a present hope,
that the past has no reality other than as a present memory.'
Jorge Luis Borges, 'Tlön, Uqbar, Orbis Tertius', 10

Sheila Ayearst and General Idea announced both this book as a whole and this first chapter's concern with the specifics of art-historical referencing. In turning now to discussions of work by Allyson Clay, Chris Cran, Andy Fabo, Joe Fafard, Murray Favro, Greg Ludlow, Joanne Tod, and Claude Tousignant, I will examine in greater detail the intricacies of what I see as quintessentially postmodern memories of art's past. Contemporary art can and does cite its aesthetic forbears in a dizzying variety of ways and for any number of reasons, as we have already seen. To point to just two well-known examples from American and European art, this practice can take the form of Sheri Levine's photographic duplications (but can memory ever strictly duplicate?) of seminal—usually modernist—work, or, in a quite different vein, Anselm Kiefer's reflections on his German heritage. In recent Canadian practice, a partial list of works thematizing citation would include Robert Adrian's installation *Great Moments in Modern Art II*

(Joseph Beuys Crashes in Russia, 1943) (1984), which imagines Beuys's crash as the beginning of the influential German artist's quest for spiritual redemption through art; David Bierk's less optimistic painting called *Save the Planet/Autumn Sunset to Keith and Caravaggio* (1989), where a detail showing grief and lament from Caravaggio's *Death of the Virgin* is set against a lurid, ominous Baroque landscape; Sorel Cohen's inscription of David's *Madame Récamier* in *Re-reading two Empires* (1989) or Gail Geltner's use of Ingres in *Closed System*. Perhaps the most controversial work of this sort is Attila Richard Lukacs's *Junge Spartaner Fordern Knaben zum Kampf Heraus* (1988), with its borrowings from Degas and Caravaggio. Memorials to past art are also used for varieties of contemporary commentary in pieces as otherwise different as Carol Wainio's abstract, bifurcated recollection of landscape imagery entitled *The Sight (Site) of a Memory Trace* (1985); Robin Pek's re-makes of Donald Judd sculptures; David Thomas's performance entitled *Lecture to an Academy* (1985), which is reminiscent of eighteenth-century views of academic study, like those of Zoffany; both Jeff Wall's and Ian Wallace's frequent formal and social allusions to the European avant-garde, and Michael Snow's photographic series *Plus Tard* (1977), in which the reputation and continuing presence in cultural memory of the Group of Seven is examined. Many of these works—Wall's cibachrome print *The Storyteller* (1986), for example, in which the marginalization of native culture is addressed—use allusion for laudably serious ends that go well beyond the boundaries of any art discourse. An earlier but relevant example (given the controversy over the chronological beginnings of postmodernism) is the late Jack Chambers's homage to seventeenth-century Spanish realism in *Madrid Window No. 2* (1968-9), in which a still-life by Francisco de Zurbarán is fused mnemonically with an image of Chambers's wife and child. Other contemporary artists are more playful in their engagement with what nonetheless remain important social issues. Snow's blurred images of icons by the Group of Seven suggest that present viewers are indeed too late to appreciate fully the power these landscapes had in early twentieth-century English Canada, and that it is past time for us to look beyond this sort of work. Yet Snow shows that we do recall and that our memories change in light of present concerns. A greater ludic extreme is achieved by General Idea in their installation *Snow Bird: A Public Sculpture For the 1984 Miss General Idea Pavilion*, executed in 1985. Not only is history revised (this work wasn't part of the 1984 exhibit), but the birds—made from Javex bottles and hung in a stairwell—mock several staples of Canadian culture: Michael Snow's famous Canada geese in the Toronto Eaton Centre, Anne Murray's song of the same title, and the Canadian Air Force's acrobatic team.

Another refreshingly playful locus for a certain sort of memory of art history is Joyce Wieland's combination of a Painters Eleven abstract style with undercutting erotic iconography in early works like *Redgasm* (1960) and *Notice Board* (1961). Art-historical citation is not new in Canada, then, but it is becoming more pointed and self-conscious.

These few examples indicate the range of implication open to art-historical referencing. Without claiming to do justice to the nuances of memory involved in this typically postmodern enterprise, I want to emphasize here only two general modes of art-historical recollection. In *Three Minutes* and *The Unveiling of the Cornucopia*, reference is made to art quite removed temporally from today's artist. This is also true of Fabo's *The Craft of the Contaminated* (1984, Plate 3), and I have suggested that many aspects of postmodernism's characteristic reconstruction of the past through memory can be illuminated by this first sort of citation, with its relatively long memory. As many commentators have observed, however, the 'modernism' in the term postmodernism ties our understanding of the latter notion to a more recent past and to working (not to say final) definitions of modernisms, and this is the second mode I will consider. Both are highly controversial.

Fabo's *Craft of the Contaminated* reminds us with its forms, and with its recollective rhyming of 'craft' and 'raft' in the title, of one of the renowned 'masterworks' (I use the term advisedly) of Romanticism, Géricault's 1819 *Raft of the Medusa*. What is the status of this European cultural heritage, however, when Fabo has parodically substituted stereotypically Canadian icons like our flag for Géricault's highly specific indictment of the ethics and politics of a Royalist sea captain abandoning would-be French settlers off the coast of Africa in the early nineteenth century? In what senses is Géricault (and the inheritance he stands for) a 'master' for Fabo, or Canada, or the viewer? One way to respond would be to side with those who see postmodernist memory as pastiche, to claim that there is some 'real history' represented by and in the Géricault, and thus that Fabo is simply toying with forms and ideas, borrowing what he likes. But such an answer would, I believe, wilfully disregard the particulars of Fabo's quotation and the cogency of his memory's work as it constructs what he calls 'cultural collisions'.[1]

Fabo's *craft* is indeed that of an epigone in that current technology allows him access to so many images from art's past, but this does not mean that his choices are random and therefore empty, as theorists of an ahistorical postmodernism so often assert. His craft—as opposed to academic high art—is certainly not pure. It is 'contaminated' by knowledge, by memories of what has happened in art and society since 1819. Thus in

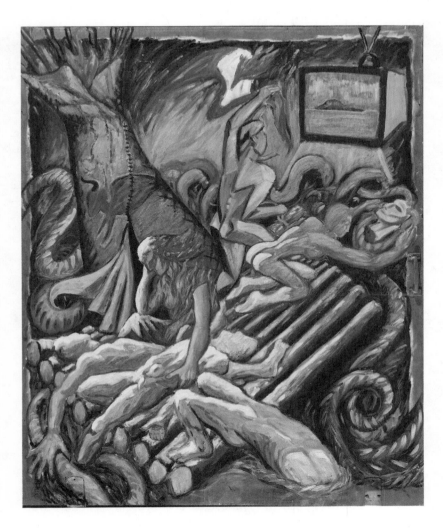

3 Andy Fabo,
The Craft of the Contaminated (1984)

doubling[2] the title—Fabo symbolically pollutes the painting by adding a 'c' to the 'raft'—and the look of Géricault's painting, he comments both on the cultural strife of contemporary Canada and more generally on the use of the past in the present through art. It is clear that the images he deploys cannot be personal memories alone. The Canadian flag, the teepee, the Lawren Harris-like island landscape on the TV, all are hackneyed formulas for national identity already provided for us. As Fabo has written, 'Whatever is truly local in particular works of art today is usually invisible or, at best, barely discernible. Anything that can be easily seen and named is actually a cliché, one of a proliferating number of blunt signposts that have long since left local culture to join the global' (71). Is it possible, Fabo seems to ask both in the painting and in this article, to return to and capture an originary, solid 'Canadianness' amidst the proliferation of already-determined meanings? One comparison in the painting would suggest not. On the raft is a teepee—itself an image of native Canadian culture as mediated by Europe in the latter's constant self-presentation as authoritative and authentic—and on this 'canvas' is the representation of a prehistoric-looking bison. As in *The Unveiling of the Cornucopia*, we are given the look of the past. This 'primitive' representation is contrasted in *The Craft of the Contaminated* with the Group of Seven landscape presented through contemporary technology on the TV screen. Yet neither image nor mode of presentation—past or future in terms of technology and in terms of the theme of hoped-for rescue made clear by the grey figure waving the flag at the screen—seems able to save those on the raft.

Fabo laments this impasse in terms that can be understood as a richly metaphorical evocation of his own painting:

> We're all awash in a sea of information clinging desperately to our small craft. . . . We are all carriers and the waves incessantly pound against our raft. We have built a small shelter, it's true, a lean-to made of timber and canvas, and we take turns warming by the fire, but by and large we're exposed to the elements most of the time. Someone, just now, shimmies up the mast and waves an ignited flag—pantomiming the sighting of land. (73)

Fabo's memory of Géricault's image of despair and his overlaying of Canadian cultural clichés leaves us with a picture of the postmodern world as a place of endlessly circulating signs and simulations reminiscent of Baudrillard's thinking. The fit between this new and contaminated craft—in the sense both of raft and of cultural production—and *The Raft of the Medusa* is precise. Where Géricault shows us the excruciating moment in which a potential rescue ship is seen by (but does not yet see) the

castaways, Fabo too signals the futility of flag-waving, since the sighting of land—anything 'solid' in the maelstrom of signs—is only mimed. It can't be 'real', because the image is simulated.

I would like to suggest, however, that Fabo's localized citational gestures—despite their inescapable dependence on already-circulated signs—are not inevitably futile. His habitual mixture of personal and art-historical memories in a canvas like *Medicine Man Memory* (1986), with its invocations of Emily Carr's fecund landscapes overlaid with Haida and Kwakiutl artefacts, suggests that hope for change underlies and motivates Fabo's reflections. This future orientation for the past can arise unexpectedly. Looked back on from 1990, for example, *The Craft of the Contaminated* changes in our memory. Even if we don't know about Fabo's activism (discussed in Hutcheon's essay), the notion of 'contamination' in this painting is now linked to the AIDS crisis. Where an art-historical allusion 'originally' bespoke the (merely) semiotic infectiousness of European high culture, the presentness of issues surrounding AIDS will, I think, literally change the picture for most viewers. We will likewise re-read Fabo's description of those on the raft as 'carriers'. The references to contamination no longer suggest only the problems of art-making and the making of one's personal and national identities through art. Over these meanings—now memories, perhaps, just as the Géricault is a memory—is laid a more pressing threat of contamination. Society's constant recourse to this pejorative description of the disease is itself of course a politically reactionary reminder of earlier 'plagues', and AIDS is taken by many merely as a sign of late twentieth-century culture's well-deserved apocalypse. But the disease is obviously much more personal and tragic in its effects that any of the images in *The Craft of the Contaminated* could be when construed in Baudrillard's aestheticized terms. Memories of intervening events have transformed Fabo's citation of art's past into a social commentary that goes beyond the semiotic. To suggest—as one critic of Fabo's work has[3]—that postmodernism is a monolithic entity that has concluded 'that the body has disappeared' is to disregard the complexities of the phenomenon's mnemic possibilities in favour of an easy dismissal.

London artist Greg Ludlow's *All Conditions Are Temporary* (1984; Plate 4) thematizes memory's dynamism, its function as the constructor and reconstructor of those ways of thinking we call the past and history. As in all the works we have considered so far, allusions to the history of art are visible. The entire piece is something of a homage to Russian Constructivism in its manipulation of forms that are at once iconic and non-objective, like the 'x', the circle, and the triangle. Much more covert is

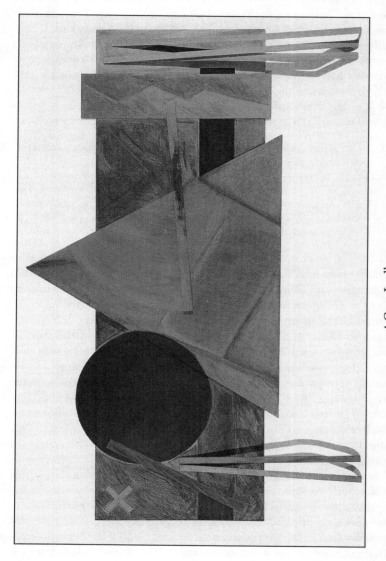

4 Greg Ludlow,
All Conditions Are Temporary (1984)

Ludlow's allusion to the anthropomorphized, proto-Cubist angles of Picasso's *Demoiselles d'Avignon* (1907) in the flesh-and-blood coloured vertical panel at the extreme right. Such a seemingly wilful combination of historical references again invites the label 'pastiche'. Though with a less socially-minded impact than Fabo's *Craft, All Conditions Are Temporary* also avoids the charge of being ahistorical by illuminating how memory (the artist's and the viewer's) makes and re-makes its own past by constantly re-evaluating the status of what we deem to be historical.

We can discern this movement from potential pastiche to meta-historical reflection in Ludlow's own description of his artistic practice:

> The masterpieces of art have been handed to me as equal objects, either through reproductions found in books or magazines, or as slides projected on a screen. It follows that I have an attitude that is somewhat suspicious of art history's demonstration of the 'masterpiece'. Much of my work is physically unstable or lacks a fixed presentation. This strategy anticipates and confounds any attempt to apply once and for all time a particular meaning to an individual painting. (no pagination)

He begins by claiming that all past work is presented as equivalent despite the hierarchies of art history, but he reasons and paints his way out of this rather easy pluralist position by asserting the flux of that assignment of meaning by which art history itself is created. *All Conditions Are Temporary* enacts memory's work on the (supposed) verities of Constructivism and Cubism. The title—doubled in the kinetics of the work—announces the mutability of past, present, and future. The 'conditions', both aesthetic and social, of Cubism and Constructivism were and are indeed temporary when recalled by a painterly present that is itself the locus of change. And if conditions were and are temporary, they will remain so in the future. Like so many artists before him, Ludlow here recalls both earlier art and previous aspects of his own art. What distinguishes his memory as postmodern, however, is his lack of nostalgia for anything constant, whether Picasso's yearning for the power of 'primitive' expression in the *Demoiselles* or the Constructivists' vision of a utopian state realized through abstract art. *All Conditions* is a machine for the perpetual renewal of art: the 'off balance' stick pivoting just to the right of centre seems to apply a fresh swatch of pigment to the triangle, the supposedly (but no longer) immutable Platonic solid that commands this work. In this action and in the consciously unstable and unfinished look of the entire painting we see the constantly renewed projection of memory as it creates new histories.

The viewer's share in this mnemonic reconstruction through art is

crucial, as we have seen. Because of intervening events, we always in one sense know more about the past than was known when that past was its own present. Without such subsequent events to elicit recall, that past will be forgotten. In this way, then, re-viewing is the norm and it creates pastness and history—Ayearst's Rembrandt today, Fabo's Géricault today. But questions remain. What is the import of what Michel Foucault called the 'author-function' ('Author', 107-8), the sense that a unitary designation—'Picasso', for example—can be remembered by a unitary subject called 'Ludlow', if someone looking at a work sees an art-historical (or indeed any other) allusion not initially seen by the artist in question? To make this point about memory concrete, we might ask how we evaluate the coincidence of the prominent sticks leaning against *All Conditions Are Temporary*, which suggest its mutability, with similar forms in a Jasper Johns work from 1982 called *In the Studio*? Ludlow knows and is influenced by Johns's art—indeed, his most recent work returns to one of Johns's favourite mediums, encaustic, and again thematizes the penti-menti of memory very physically, since we can see the changes (the creative past) embedded in the wax—but (he claims) not by this specific piece. Yet they are closely related in the memory of a viewer who knows both. Questions of intention, influence, authority, and originality might arise in this common situation. Without discounting these possibilities, however, what I wish to emphasize is that viewers' as well as artists' memories change works of art by defining and redefining their modes of pastness. For the postmodern mnemonist, there is no real history to retrieve and the present therefore cannot be a pastiche of the past. Yet as the reflections on historical citation we have been discussing so clearly show, neither is the present simply the site of an empty manipulation of simulations. Even in the restricted arena of art-historical citation, memory is replete, and it works historically, personally, and politically.

In recalling Picasso and Constructivism, Ludlow's *All Conditions* does not simply reinterpret individual artists and movements that have become the historical currency of art history: most importantly, in the context of this chapter, it also memorializes that ever-problematic period distinc-tion, modernism, and it does so in what has become the form para-digmatic of modernism, abstract painting. To anchor my contentions about artistic memory's recollection of modernism, I want to consider in some detail examples of the modern-postmodern relation in Canadian painting, specifically in the crucial relationship with Mondrian's art—which I take to be representative of a primary strain of modernism—found in the work of both Claude Tousignant and Guido Molinari.

Tousignant's masterly *Hommage à Van Gogh* (1956) might seem out of

place in a study devoted to postmodernism, and I should emphasize that I of course do not see the painting as postmodern; nor am I claiming that it stands in for all of Tousignant's illustrious career. On the contrary, it encapsulates in its own homage—a particularly future-oriented form of memory directed towards keeping certain ideas and ideals alive—to van Gogh many facets of what has become, at least for postmodernist memory, late modernist abstract painting's characteristic insistence on purity—of means and of metaphysical ends. As the current work of Tousignant and Molinari (among others) demonstrates, this strain of modernist abstract painting continues to be viable critically. Yet despite the great variety of modernisms (and postmodernisms) that we can perceive—a number multiplied even more by the often-useful distinction made by Peter Bürger (1984) between the historical avant-garde and modernism—a great deal of postmodern practice reacts against this modernism-as-purity model. Against the grain, then, I am contending that there was (and continues to be) modernism in Canada, and that Tousignant's and Molinari's abstract paintings are among its most powerful instances. The Toronto curator Philip Monk claimed in a 1983 article that 'Canadian art . . . [has] passed from pre-modernism to so-called post-modernism without a history of modernism' (*Struggles*, 93). If he means to emphasize the lack of a written history to constitute the objects of this past, I would agree, but if we interpret him to mean that Canadian art lacks identifiable modernisms, then I would suggest that his view is unsupportable when we look at postmodernism's memories. My emphasis on the modern/postmodern relation, then, should be read as historical rather than as a reduction of the complexity we all know obtained in the modernist period.

Tousignant's *Hommage* is as much a memory work as any other piece in this book, but the nature of its memory contrasts strongly with what I see as postmodern practice. Clearly Tousignant remembers van Gogh's signature use of chrome yellow; aside from this reminder, however, his work doesn't at all resemble van Gogh's paintings. But a homage is by definition executed with the benefit of hindsight—in this case, with the knowledge of van Gogh's legacy for later modernist art. Speaking of his early abstract painting in general, Tousignant wrote: 'what I want to do is to purify abstract painting, to make it even more abstract . . . [until] only painting remains, emptied of everything alien to it, to the point where it is sensation alone, where it is understandable to all' (in Burnett and Schiff, 67-8). His *Hommage à Van Gogh* purifies early modern painting of figuration, leaving only the finely registered abstract sensation of 'yellowness' as the essence of van Gogh's work. His use of that notoriously difficult colour is

itself a homage to what are conceived as purely painterly problems. Van Gogh is thus recollected by Tousignant very much through the purifying filters of specific species of intervening abstract painting and art theory. This is not the 'historical' van Gogh who stubbornly resisted abstraction when it was taught by his idol, Gauguin.[4] What Tousignant shows us is another Vincent (perhaps equally historical, though in a register that has been projected back into time), one who is a father-figure in the Greenbergian theory that painting should be about itself, about self-critique, flatness, and colour.

Tousignant's *Hommage* presents us with a rigorously teleological sort of history, one that views abstraction as the inheritor and saviour of late nineteenth-century avant-grade experimentation. To purify van Gogh, Tousignant looks back not only through Greenberg's theories—the affinity is marked by Tousignant's attempt to banish from painting 'everything alien to it'—but also through the abstract modernism of the early twentieth century that is best exemplified by Mondrian. We are reminded of Tousignant's double heritage by his utopian desire to make abstract art 'understandable to all', a desire that closely mirrors Mondrian's utopian *social* aims for painting, and that thus takes us well beyond the 'formalist' purity that Greenberg is usually seen to call for.[5] For Mondrian, *all* art of the past was eclipsed by (his) abstract painting, and abstraction—far from being a mere manipulation of purified forms, colours, and relations—was itself a perfected instrument for the foundation of a new 'equilibrated' society that would embody Neoplasticism's purity. Mondrian's rhetoric of purity always sought to take art beyond its (by definition impure) materiality, to be totally comprehensible and to become one with society, as I will argue in greater detail near the end of this chapter. To be a vehicle for this extra-artistic perfection, art for Mondrian had to embody essences that were timeless and thus by definition true. But given his Platonic and Hegelian metaphysics, art as material was for him inherently mutable—in Donald Kuspit's (1981) felicitous phrase, modern art had an 'unhappy conscience'—and thus could be only a stepping stone to the purity he sought. Paradoxically, then, art for Mondrian aspired to the condition of non-art, to an immutable and atemporal goal at the end of its historical evolution.[6] What implications does this reminder have for Tousignant's homage to van Gogh? In a 1971 article, Tousignant asserted that Mondrian was the chief inspiration for his project of purifying art ('Quelques précisions', 81-4). Tousignant seeks to memorialize van Gogh timelessly in a pure, abstract commentary that will be understandable to all, not only now, but in the future. Molinari's relation to Mondrian is analogous; a consideration of his theoretical position vis-à-vis modern-

ism will again establish differences between modern and postmodern memory.

Molinari has tellingly characterized himself as 'a man for whom the absolute [is] to be authentic'.[7] Authenticity in art is for Molinari a quintessentially modernist idea inextricably linked with notions of 'purity' and 'autonomy' as proclaimed by European abstractionists in the early twentieth century. He has been consistently and remarkably engaged with the progenitors of abstract painting, coming to Mondrian's paintings and theoretical statements as early as 1951 through an article by James Sweeny in *Art News*,[8] and his interest was consolidated when he saw Mondrian's work in New York in January 1955. Even before these direct contacts, though, Molinari had been steeped in the aesthetics of Les Plasticiens, a group whose members, according to their leader, artist-critic Rodolphe de Repentigny (Jauran), drew explicitly on Mondrian in articulating their own goal of 'majestic purity and rigor' (Fenton and Wilkin, 75). The seminal *Art Abstrait* exhibition at the Montreal Ecole des Beaux-Arts in 1959—in which Molinari participated, and which he later saw as a turning point in his structural exploration of colour (Théberge, 54)—was dedicated both to the *new* Plasticiens and to Malevich, Teuber-Arp, Mondrian, and Van Doesburg (Théberge, 26). Molinari has himself characterized Mondrian's evolution of a new dynamic space as 'la grande révélation de ma vie' (Burnett, 9) and has self-consciously attempted to perfect his mentor's aesthetic discoveries; in fact, his fascination has extended to the acquisition of Mondrian's manuscript for the essay 'Purely Abstract Art' (1926).[9] Though Molinari gleaned his knowledge of Mondrian from many sources, this particular essay provides an effective entrance to the notions of purity and autonomy so fundamental to the authenticity offered by Mondrian.

'Purely Abstract Art' is a succinct statement of the key beliefs and terms that informed Mondrian's writings from early theoretical documents like 'The New Plastic in Painting'—published in *De Stijl* in 1917—through his New York texts like 'Pure Plastic Art' (1942), which first caught Molinari's attention. The title itself emphasizes the notion of purity, which was at once the goal and the method of Mondrian's art. References to nature in art, he said, could and must be 'purified' so that beauty could return to its origin in 'pure intuition' (Mondrian, 199). Taking as exemplary his own signature orthogonals, with their perfect compositional and metaphysical 'equilibrium', their purity of 'relations', we may interpret this to imply not merely a rejection of naturalism but the more radical contention that art's beauty had *perforce* to be autonomous, a '*purely abstract beauty*' (Mondrian, 199). Molinari follows this line of thinking closely, not as an

epigone (though he has been accused of this[10]), but as the heir that the master's own evolutionary and teleological historicism seemed to require. For Mondrian, abstraction was the mode appropriate to the 'modern mentality'. It is consistent, then, to see Molinari's extension of his ideas as not only suitable but (as they would both claim, in somewhat authoritarian terms) *necessary* to modernist art.

In 1961, Molinari asserted that plasticism in Mondrian's sense was the only direction that offered 'des possibilités d'évolution à la peinture du XXe siècle' (*Écrits*, 38). In this essay he willingly adopts Mondrian's evolutionary scheme of artistic progress and enthusiastically situates himself in its ongoing history. 'Abstract painting is still in a preliminary phase,' he wrote in 1966; 'contemporary art can only look forward to the elaboration of increasingly abstract painting.'[11] True to Mondrian and to his own definition of authenticity, then, Molinari set out to realize the early twentieth-century dream of an art that functioned as a self-sufficient 'language'. His highly articulate critique of Mondrian should thus be read as a shared enterprise of aesthetic purification rather than as a radical departure.

To take abstract painting into the future, Molinari set himself the task of eliminating 'the conflict between object and space, as well as the expressionistic interplay of various proportions' (*Écrits*, 42), elements that were residual in Mondrian's work, just as aspects of nature were for the early pioneers of abstraction. Even when Molinari refers to 'what remained to be destroyed in painting after Mondrian' (*Écrits*, 44), however, and proceeds to develop his own plastic language based on colour relations, his relation to his own adopted heritage is anything but negative. On the contrary, he is simply more able—because of his memory of Mondrian's example—to realize completely his forebear's annihilation of cubist space and to erase any remaining traces of anthropomorphism in the name of art's autonomy.

By inscribing themselves in the tradition of the early abstractionists—by honing art into a universal language whose purity guarantees universal communicability—Molinari and Tousignant also take on their utopian quest. This may not be conscious: Molinari, for example, has explicitly rejected 'Utopian systems . . . evolved to define "objectively" the emotional impacts of a certain colour' (*Écrits*, 89). In statements like this, however, the word 'utopian' is being used in its rhetorical rather than its political sense, as a means of discrediting claims by Kandinsky and others that certain colours evoke specific responses in all cases. What is 'remembered' by Molinari and Tousignant in their articulation of an authoritative modernism is a largely formal purity of means, with or without any

reference to a potential communication. What is unspoken, 'forgotten', from the early modern context, is the extent to which this formalism was instrumental in, and subordinate to, the realization of a social utopia through art.

But this is a paradoxical—if typically modernist in the way that Mondrian is modernist—resolution, since Tousignant's basis for universal comprehensibility is radically historicized, while his *goal* seems to be an ahistorical immutability projected into the future. How could the elegant simplicity of his homage be understood universally when its co-ordinates are so historically determined? In this contrast we can see one significant difference between a modernist and a postmodernist use of memory in referring to art's past. Tousignant uses the main trajectory of twentieth-century abstraction as a way to fix van Gogh's achievement; in the other memory works we have looked at, art-historical allusions are recalled in an impure, 'contaminated', and self-consciously historical way in order to keep the ongoing redefinition of the past open to future memories. This contrast can be seen again in a comparison of two other homages to van Gogh, Joe Fafard's bronze bust *Vincent* (1985; Plate 5) and Murray Favro's installation entitled *Van Gogh's Room* (1973-4; Plate 6).

To prepare the way for this contrast between modern and postmodern memory—which I believe speaks directly about much current art's relation to its own past—it is appropriate to consider first the nature of modernist memory in more detail. Two caveats need to be recorded. I am not claiming to describe *all* modernism; in fact, I will argue that this totalizing impulse is specifically modern in inspiration, and that it is a characteristic often rejected by postmodernist practices. Second, as Tousignant makes clear, modernist memories may be Canadian, but they are not usually focused on Canadian art.[12]

It is not unusual to read about modernism's 'absence of memory', its amnesia within a putatively pure self-presence (Deitcher, 17). But this view subscribes too readily to the *desire* of artists like Mondrian (to stay with this example) to reject completely their aesthetic pre-history, to begin anew and create a supposedly perfect art as a model for a perfect society. But as Deitcher himself points out, 'the relationship between art, memory, and history was not irrelevant to a much earlier discourse on modernism' (15): that of Baudelaire. In fact, as Michael Fried has persuasively argued in relation to Baudelaire and Manet, Western painting since the Renaissance at least 'is nothing more nor less than the latest term in a chain of memories of works of art that for all practical purposes must be thought of as endlessly regressive' ('Painting Memories', 518). In a way, then, it is remarkable that contemporary practices of 'appropriation'

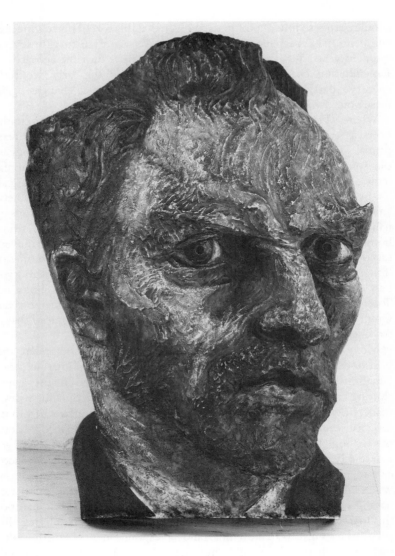

5 Joe Fafard,
Vincent (1985)

should garner so much commentary, given that this sort of borrowing and competition has been prevalent throughout Western art history for several hundred years. What *is* interesting is that the *mode* (not the activity) of remembering changes in much modernist art of the early twentieth century—particularly in abstract painting—and that it changes again nearer our own time.

Whereas Fried claims that art-historical referencing in the Western tradition was 'endlessly regressive' in the sense that it led back 'to no ultimate or primal source or prototype' ('Painting Memories', 518), I want to suggest that somewhat later modernist practice expressly sought to end this infinite regress both by looking for the essence of painting and by transcending all art by founding a perfect, static state that no longer required aesthetic amelioration. We have seen both moves with Mondrian and with Tousignant and Molinari. It is not that they forget the past—quite the opposite in a homage—but that their memories seek to establish an absolute and universal condition that is so totally transparent as no longer to need memories of difference and change. Because of its temporal projection, their memory is best described as memory of the *future*. But again, questions intervene. Tousignant's memory of van Gogh is potent, but must we all remember van Gogh as yellow and flat? Is this not a particular historical memory that is striving—against the odds—to escape history?

Memories of art's past, then, are crucial to both modernism and postmodernism—and for this reason alone I mistrust the numerous proclamations of a 'break' between these mnemonically created and thus ever-shifting entities. Depending on the selections and points of comparisons made, however, postmodernist memory can look very different from its modernist relatives. This is certainly true if we compare the recollections of van Gogh by Tousignant, Fafard, and Favro. Like *Hommage à Van Gogh*, Fafard's 1985 *Vincent* is a portrait of the past master consciously produced as a memorial. 'I'm not trying to place myself in this or that tradition when I do a portrait of van Gogh,' Fafard reports. 'I see myself rather as paying a kind of homage to this particular guy, who was the originator of this marvellous work' (Teitelbaum and White, 53). Fafard emphasizes his personal response to an individual, and he responds in *his* specialty, sculpture, rather than in van Gogh's, in order to hypothesize 'what van Gogh would have done had he become a sculptor' (37). Fafard's homage particularizes van Gogh where Tousignant's universalizes him. Like almost all of Fafard's portraits of famous artists done since the early 1980s (the exception being *Gauguin* from 1986), the subject is treated reverentially in that the techniques of which the artist portrayed was the 'originator' are imitated. We see van Gogh's vigorous handling of pigment on Fafard's

bronze surface. Most importantly in comparison with Tousignant's van Gogh, *Vincent* is about as physically flat as a portrait sculpture can be, flat in a way that suggests impasto relief and which from the proper angle creates an illusion of depth, as do van Gogh's own portraits and land-scapes, which are nonetheless not absolutely flat.

Tousignant's memory of van Gogh has the admirable seriousness of a metaphysical proposition; Fafard's recollection—like most of his work—has the amiable good humour of a strictly individual compassion for an artist whose life was too tragic to allow for ludic interventions. The medium and the planarity work together to achieve this sensitive light-ness of effect. Fafard *puns* with the notions of surface and depth by literalizing them, just as (in the example Teitelbaum emphasizes in this regard) he puns with Clement Greenberg's call for flatness in painting by making a flat—and thus if one remembers it side-on, decidedly narrow—sculpture bust of that critic called *My Art Critic* (1980). Fafard's techniques and familiar, indeed overtly 'appropriative', titles (*My Art Critic, My Picasso, Clem, Dear Vincent*) do not claim universal meaning. They revel in the idiosyncrasies of personal, local recollection. An analogously ludic appro-priation of a modern master(piece) is Calgary painter Chris Cran's *Self-Portrait as Max Beckmann* (1986), in which he substitutes his own face for that of Beckmann and thus effectively denies the autonomy and sense of self-possession asserted so strongly by Beckmann.

Murray Favro's installation *Van Gogh's Room* (Plate 6) makes this play with a past artist and image even more palpable by allowing himself and then the viewer actually to enter the space of one of van Gogh's paintings, *Van Gogh's Bedroom* (1888, Amsterdam). Favro reports that this painting is one of his favourites because of its unusual space. His homage takes the form of a life-size reconstruction of this very personal space—van Gogh's bedroom in his beloved yellow house at Arles, the centre of his fantasy for an artists' colony. But where van Gogh was held by his medium to only one, flat view of this room, Favro's three-dimensional recollection allows us, in his words, 'to be able to view van Gogh's painting from other vantage points' (Fleming, 76). Favro employed his now-famous projec-tion technique to accomplish this transformation. Onto a mock-up of the room that coincides in its irregularities with the space depicted in van Gogh's painting, he projects light through a slide of *Van Gogh's Bedroom*. This projection does of course make the painting present to our memo-ries, even though it is not a painting that we see, or even a slide of a painting. More important than this literal enlightenment are the meta-phorical ways in which, as Favro claims, 'projection is analogous to the way we project meaning onto objects' (76). What I wish to propose is that

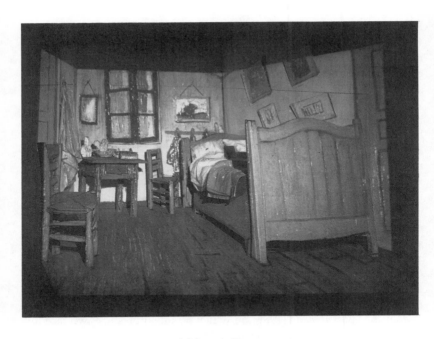

6 Murray Favro,
Van Gogh's Room (1973-74)

Favro's practice of 'projection' ingeniously captures the way a postmodern *memory* works to construct meaning.

As Marie Fleming suggests in her 1983 catalogue on Favro's work, there is no way in which this projection provides us with an original or essential van Gogh or van Gogh painting (74). The artifice of the installation is made manifest: it is another mnemonic machine for creating art and meaning through art. As viewers, we are aware of the *constructed* nature of the work immediately. We can walk into it, we can see the projector at work, and, most significantly, we can physically duplicate the forgetting crucial to any art-making simply by walking in front of the projected image and thereby cutting off part of the work. Memory projects in analogous ways when it recalls its art-historical past. An 'object', say *Van Gogh's Bedroom*, is re-collected, brought into the present, because of whatever current contextual circumstances have spurred the reminiscence. As with Favro's homage, though, there is no original to collect, only mnemonic traces to retrace. Parts are necessarily emphasized and forgotten in each redeployment. Three other similarities should be emphasized, each of which tells us something about memory's construction of the past. First, it is not just the artist's memory that works here; s/he is not autonomous, because different viewers will move differently in and around Favro's room, projecting different meanings. This sense of movement underlines my second point: projection is not only a matter of sight. In spite of the importance of light, corporeal memories are also registered as we interject ourselves into the work. Finally, as the materiality of Favro's installation witnesses when the projection is turned off, neither the artist nor the viewer is free to project just any memory. Specific objects are there to receive meaning (though not just one meaning, nor meanings that will never be superseded) and these meanings, though both personal and various, are by no means strictly the property of any single artist or viewer, both of whom necessarily work with and within socially and institutionally validated codes. We must be aware of the sense in which van Gogh projects *us*, even though the manner of this prophetic determination will vary with our own memories. When a postmodern art like Favro's looks back to its own traditions, all conditions are indeed temporary, but not arbitrary.

The works by Allyson Clay and Joanne Tod included in this chapter embody yet other sorts of memories of art's past, memories that (like Ayearst's alone in the works discussed so far) are strongly inflected by the difference in gender of the female artist in the present and the male antecedents she cites. Unusual as well are their allusions not to specific works but to the conventions of an entire modernist tradition, abstract

painting. Both feel keenly the weight of inheritance. Exemplifying the possibilities of the complicity/critique predicament, however, Clay and Tod re-evaluate painting as a genre by remembering differently its unsavoury gender assumptions and exclusions. As painting addressing painting from women's perspectives, their postmodern work is especially close to modernist paradigms, which have (rightly or wrongly) largely been codified in this medium. I have therefore consciously emphasized painting in this chapter not only to counter the (much exaggerated) assertions of its demise, but also to show that recent critiques of modernism very often take place within painting's own frame of reference.

Allyson Clay's *Lure* (1988; Plate 7) was originally installed with the four small abstract paintings facing a complementary set of four texts across a space. Because we have illustrated only a detail of this work, only (portions of) Clay's texts can be cited, making their relationship to the corresponding paintings at once more enigmatic (it is difficult to 'read' both at once) and more flexible (since the positioning of the viewer with respect to the abstract paintings is less determined, allowing him or her to read image and text in any number of combinations). Each text describes, in apparently neutral language, how to construct the abstract across from it. The texts thus memorialize this recipe, just as the paintings are material reminders of the texts' instructions. Neither is primary. Embedded in each text—not unlike the inscribed memory of the brain's death on the right side of *Three Minutes*—is a countertext, a passage sometimes set off typographically, as in the fourth image/text pair (called 'Eye to Eye'), and which in all cases contrasts in its emotional intensity with the seemingly cool and straightforward preparation of the abstract image. One painting places the form of a cross against a white ground. In the related text, Clay interweaves a horrifying story about the martyrdom by fire of St Cecilia, a story that—in our memories and hers—inevitably transforms the 'abstract' cross into a religious symbol. Clay's own recall further exemplifies and enriches this mnemonic reconstitution. The cross itself is reminiscent of her own earlier and more overtly emotional abstract paintings like *Constellation of the Great Owl* and *Cross by the Sea* of 1985. Even more importantly, the martyrdom is recalled in terms of the similarly cruel immolation of British soldiers in a colosseum in Northern Ireland, an event that occurred—and lodged itself in Clay's memory—not long before she began *Lure*.[13] History, both religious and political, is made to intervene in the supposedly 'pure', self-contained (and self-satisfied?) generation of abstract art.

Clay seems at once to be seduced ('lured') by the aura of abstraction and to feel a need to disrupt its normalities, to 'have an argument' with this

I Using either cedar, hemlock, pine or fir, build a stretcher with bevelled edges I
touch 3" square and 1 3/4" deep. Over this stretch medium weight linen · read
your and size with rabbit skin or hide glue. Prepare the glue by softening that
mouth glue crystals in water in the proportion of 1 3/8 oz of glue to one , art
face of water and heat in a double boiler until dissolved. Apply two inspired
to coats to the raw linen. Prime with manufactured lead or flake white him
face thinned with turpentine. The primer coat will dry in about 48 hours, to
breath after which the surface is ready to be painted on. Make a prove
to medium out of beeswax and linseed oil by measuring 4 fluid oz of he
mind linseed oil and adding beeswax until the level of the oil reaches was
to (do not allow to boil) and cool this to room temperature. On a glass charge
wet 4 1/2 oz. Warm this mixture in a double boiler until the wax dissolves in
wet or marble surface, use a muller to grind carbon black pigment into even
myth portions of this medium alternated with small amounts of pure if
of cold-pressed linseed oil until the consistency is thick but tractable. it
her Next make white paint by mulling titanium or zinc white pigment required
always into the linseed oil and wax mixture alternating with pure occasional
yes linseed oil as before until the paint is thick and tractable mutilation
look On the dry lead white surface draw two vertical lines with graphite to and
not divide the surface into thirds vertically. Divide each of these penetration
at three columns into three equal vertical columns by drawing vertical lines of
but in graphite. Paint every other column white beginning with the second the
into column from the left. While the white paint is still wet, paint the surface
me rest of the columns black. There will be five black columns including with
eye two on the left and right outer edges, and four white columns, all gentle
to of equal size. Make sure all edges are clean and even. strokes

7 Allyson Clay,
'Eye to Eye', from *Lure* (1988)

tradition, as she puts it. More specifically, she writes, 'it is necessary to reveal some of [the] implicit historical hierarchy in order to be able to claim painting as a viable territory for an alternative set of values which are not primarily defined within patriarchy' (*Lure*). She discloses the specifically gendered hierarchies of abstract painting most forcefully in 'Eye to Eye', the final image/text coupling, where the formula for creating the abstract image is flanked by two radically different texts. On the right, Clay inscribes her memory of a line from a contemporary painting manual—'I read that art inspired him to prove he was in charge even if it required occasional mutilation and penetration of the surface with gentle strokes'—a passage that graphically if unself-consciously demonstrates painting's violently invasive, gendered dominance over a passive medium. On the left, by contrast, Clay inscribes a gently erotic evocation of what seems more like a relation between two people than between artist and canvas: 'I touch your mouth / face to face / breath to mind / wet to wet myth of her always / yes / look not at but into me / eye to.'

Clay's strategy is to interject different voices into what she sees as the patriarchal tradition of abstract painting and thus to make it possible for women to work in this area in good faith. I have suggested that Clay's memory in *Lure* is of the masculinist conventions of abstraction, not of specific artists or works. To understand more completely her implicit assertion that this tradition is masculinist, we can turn again to Mondrian, first because his utopian expectations for abstraction's ability to effect social reforms make him one of this genre's 'fathers', and second because Clay feels herself part of this heritage through the mediation of artists like Ian Wallace, whose early abstract work paid homage to Mondrian. Inheritance—as we will see in this further recollection of Mondrian's art theory—is a primary issue when we consider Clay's relation to modernism.

Mondrian dedicated his essay 'Neo-Plasticism: the General Principle of Plastic Equivalence' to 'the men of the future'. Of course this projection of his work into the future was part of his revisionary zeal, and we might thus not take the dedication to 'men' as exclusionary of women. Looking more closely at his theories, however, we see that Mondrian did indeed wish to confine his inheritors to men, that women were part of the impurity he saw all around him and wanted to purge. My claim is that the discourse of purity that he (and others like Malevich, Robert Delaunay, Kupka, and Kandinsky) established for abstract painting very much excluded (and still excludes) non-masculinist practice from this field.

As we have seen, Mondrian's thinking about and production of art are founded on a dialectics of purification. The most excluded principle, and individual, of all within his system is the female. He theorized about the

inferiority of the feminine in some of his earliest writings and devoted the lengthy concluding sections of his first major statement of the axioms of Neoplasticism, 'The New Plastic in Painting' (1917), to a detailed defence of what he considered the intrinsic 'maleness' of abstract art. He seems obsessed with the relation between male and female even earlier in the aphoristic comments of the 1912-14 *Sketchbooks*, notes that constitute the seeds of his later art theory. 'Woman is against art, against abstraction . . . in her innermost being,' he announces (Joosten and Welsh, 19). Try as she might, a woman is 'never completely an artist' (34) because her defining feminine principle, Mondrian holds, is passive, form-receiving 'matter' or material, whereas the male is imbued with 'force' that shapes this material according to higher principles (24). In 'The New Plastic in Painting', Mondrian reveals his authority for these lamentably conventional views.[14] 'Ancient wisdom', he tells us, 'identified the physical, the natural, with the female, and the spiritual with the male element' (Mondrian, 56, n. 'g'; 57, n. 'l'). As Mondrian also makes clear, the female is to be seen as individual and the male as universal. These views are, of course, Greek, specifically Aristotelian and Platonic,[15] and in Mondrian's case they were very likely transmitted by Theosophy.[16] But Mondrian is not content merely to follow this tradition: he dedicates himself to it with an energy sufficient to generate the novel claim that woman also embodies 'tradition', both in its general cultural sense and in the visual arts specifically (57, n. 'l'). Thus the feminine principle—which he sometimes distinguishes from the biologically female by claiming that women and men have both female and male principles in their makeup, but which at other junctures he conflates with the simply mundane woman—works for Mondrian as the initially negative pole within an unbalanced economy searching for equilibrium.

The feminine is the outer that opposes the male's inner values, Mondrian holds; it is material where the male is spiritual; plastically, it is horizontal (like the earth) where the male is vertical (aspiring to the Divine). These metaphysical speculations quite literally established the oppositions and purifications so common in Mondrian's signature neoplastic compositions, with their rigorous orthogonal intersections. With a quintessentially Hegelian flare, Mondrian argues that this 'negative' opposition provided by the female is actually the positive precept in the dialectic of spirit's evolution, since it stimulates the male to transcend the material altogether:

> In our time, oppression by the female, a legacy of the old mentality, still weighs so heavily on life and on art that there is little room for male-female equilibrium. As *tradition*, the female element clings to the old art

and opposes anything new—precisely because each new art expression moves further away from the natural appearance of things. Consistently viewed, the female element is hostile to all art on the one hand, while on the other it not only realizes the art–idea but reaches toward art (for outwardness reaches toward inwardness). It is precisely the female element, therefore, that constructs art, and precisely its influence that creates abstract art, for it most purely brings the male to expression. (68-9, n. 'l')

Eve is necessary to Adam, as Mondrian the Calvinist notes in this context, lending Biblical authority to his views, and like Adam, Mondrian is genuinely nostalgic for what he envisages as the equilibrium of pre-lapsarian unity. Someone of a Neoplatonic or a Jungian persuasion might condone what Mondrian sees as this acknowledgement of his *own* feminine side. But with his essentialist nostalgia comes the indelicate, exclusionary mechanism of purity, a mechanism that is decidedly patriarchal in its subjugation or appropriation of the feminine in the name of equilibrium and reason.[17] Mondrian's method is ruthless: 'we must reject nothing of the past but must purify everything' (363). His prime target, of course, is the material, individual, *female* principle for which he harbours venomous scorn: 'the feminine and material rule life and society and shackle spiritual expression as a function of the masculine. A Futurist manifesto proclaiming hatred of *woman* (the feminine) is entirely justified' (137).

With *Lure*—and with parts of her more recent work 'Paintings with Voices' of 1989—Clay seeks to 'contaminate' the vision of a pure, masculine art. Her individual, historical, and even erotic memories intervene and offer abstract painting as a field of possibility to a wider constituency than Mondrian's men of the future. Toronto painter Joanne Tod accomplishes an analogous feat with *Reds on Green* (1978; Plate 8), though humour is her way into the issues surrounding the possibilities of painting, and her target, in this instance, is the more recent hegemonic inheritance of abstract painting.

Given only Tod's title for this work—'Reds on Green'—we might expect a colour field painting emphasizing the 'pure' concerns of the medium. Paradoxically, just *looking* at Tousignant's *Hommage à Van Gogh*, we might expect it to carry a title like 'Yellow on Yellow'. The humour in Tod's piece depends upon just this anticipation, an anticipation that in turn relies on a shared memory of the widespread expectation in the Toronto art world of the early 1970s that abstract painting of a certain sort *defined* painting. Tod thwarts and mocks this supposition as she recalls with this work her own education at the Ontario College of Art. *Reds on Green* is radically figurative—it illustrates a fictive meeting between Chinese communists ('reds') that takes place against a green backdrop. The

8 Joanne Tod,
Reds on Green (1978)

playfulness of this piece is enhanced by its parodic attention to all the then 'correct' elements of painting: the 'reds' are carefully set against the hard edges of the green field in the upper part of the painting (so much so, in fact, that their heads are squared off to fit the design). Even the seamless frame is (from the vantage point of 1990) a relic of late modernist precision, modelled as it is on the 'high tech' frames Tod saw when she worked at the David Mirvish Gallery in the 1970s, a gallery that represented the tradition of mid-twentieth-century American abstraction. But unlike Tousignant's *Hommage à Van Gogh*, which (with other works from this period) pioneered many of the techniques and goals of field painting, Tod's work is anything but a homage. She pays her respects to what she saw then as a formalist enterprise, but the fictitiousness and figuration of the (mock) history painting that she created demonstrate her freedom with and from her immediate past, her inheritance. Tod's memorialization of this tradition is thus only an effect of her critique of painting's then very confined possibilities. Her tone here is certainly playful, but as in Clay's *Lure*, we receive a serious message about painting's potential for new relationships with its own history. Memory does much of the work in effecting these new possibilities and also in configuring the subject as both artist and viewer, a pressing concern in much of Tod's work. In moving now into the second part of *Remembering Postmodernism*, I want to emphasize the continuity between the concerns for the past and for the subject by focusing first on another work by Joanne Tod.

NOTES

[1]Conversation with Fabo, 30 October 1986.

[2]On doubling, allegory, and postmodernism, see Owens (1980).

[3]Dot Tuer, 'The Embattled Body: Aids and the Current Crisis of Representation', *Canadian Art* Summer 1989: 23-4.

[4]On the stormy relations between van Gogh and Gauguin over the new practice of abstract painting, see Cheetham, 'Mystical Memories'.

[5]This is not the place to go into the often-reduced subtleties of Greenberg's ideas. To my mind, the best discussions of these influential ideas are to be found in Clark (1982) and Fried (1982).

[6]For a detailed account of this rhetoric of purity and the advent of abstract painting in Europe, see Cheetham, *The Rhetoric of Purity*.

[7]From an unpublished manuscript entitled 'Projet but absolut' (October 1952), cited in Pierre Théberge, *Guido Molinari*, 7.

[8]See Robert P. Welsh, 'Mondrian and the Science of Colour and Line', *RACAR*, V, 1 (1978), 5.

[9]See Harry Holtzman and Martin S. James, eds and trans., *The New Art—The New Life: The Collected Writings of Piet Mondrian* (Boston: G.K. Hall and Co., 1986), 198, n.3.

[10]See for example F. Gagnon, 'Mimétisme en peinture contemporaine au Québec', *Conférences J.A. de Sève*, 11-12 (Montréal: Université de Montréal, 1971), 39-60.

[11]Molinari, 'Statement', *Canadian Art* 23 (January 1966), 64.

[12]An interesting exception might be Fabo's citation of Harris, who is arguably a Canadian modernist.

[13]I have this information from a conversation with the artist on 4 May 1988.

[14]Mondrian could have found these and related denigrations of the feminine in innumerable sources in the late nineteenth and early twentieth centuries. See, for example, Bram Dijkstra's discussions in *Idols of Perversity: Fantasies of Female Evil in Fin-de-Siècle Culture* (Oxford: Oxford University Press, 1986). What I find most interesting, however, is his use of Plato as his source.

[15]Plato equates matter and the feminine in the *Symposium* (190 b) and *Menexenus* (238 a).

[16]For a general discussion of Mondrian and Theosophy, see Welsh, 'Mondrian and Theosophy'. Welsh does not discuss Mondrian's exclusion of the feminine.

[17]Londa Schiebinger presents what I see as an analogous explanation for the historical personification of Science as female. 'Scientia', she argues, 'is feminine in early modern culture . . . because the scientists—the framers of the scheme—are male: the feminine scientia plays opposite the male scientist' ('Feminine Icons: The Face of Early Modern Science', *Critical Inquiry* 14 [Summer 1988]: 675).

II. REMEMBERING THE SUBJECT

'Memory is what leads us on to the objects of our desire.'
Plato, *Philebus*, 35d

'Memory . . . is not a psychical property among others; it is the
very essence of the psyche: resistance, and precisely, thereby,
an opening to the effraction of the trace.'
Jacques Derrida, 'Freud and the Scene of Writing',
Writing and Difference, 201

Joanne Tod's *Approximation* (1988; Plate 9) is a pivotal work in this book, just as this second chapter is the fulcrum for the reflections on memory that precede and follow it. *Approximation* is the most recent of the three Tod images included here (*Reds on Green* is from 1978; *The Damage is Done*, which, as we shall see in Chapter III, is only partly 'Tod's', carries the date 1986). By considering it in the structural middle of this text instead of last, where it would come chronologically (that is, according to traditional art-historical schemes of artistic development), I hope to emphasize once more not only the thematic nature of these reflections on postmodernism and memory in general, but also the ability that *spatial* memories have to disrupt the normally linear mnemonics of *time*. Analogously, it could be argued that the focus of this chapter, the mnemic construction of the 'subject', s/he who creates and receives an image, should have been examined before we looked at what can be construed as one of the subject's

9 Joanne Tod,
Approximation (1988)

products, the remembrance of art's past (Chapter I). But this would be to adopt a teleology that runs against the grain of both memory's and postmodernism's characteristically disruptive work. My claim is that the construction of the subject through memory is pivotal—but not therefore primary or originary—in relation both to the quotation of art's history that we have considered and to the social and political implications of memory, to which I will turn in Chapter III.

It is fashionable these days, in the wake of recent poststructuralist and psychoanalytic thinking, to speak of a 'de-centred' subject instead of the (supposedly) stable and masterful 'I' of the humanist past. As Donald Preziosi has recently argued:

> The discipline [of art history] is grounded in a deep concern for juridico-legal rectification of what is proper(ty) to an artist and thereby involved with the solidity of the bases for the circulation of artistic commodities within a gallery-museum-marketplace system. [This concern] works toward the legitimization and naturalization of an idealist, integral, authorial Selfhood without which the entire disciplinary and commodity system could not function (33).

There is no question of returning nostalgically to an unexamined, idealized sense of the subject as transparent to itself (how can we ignore Freud's invention of the unconscious?) and in control of its own destiny (how can we forget the Marxian emphasis on class domination?). Rather, what a concentration on modes of artistic memory as builder and re-builder of the subject emphasizes is the ever-dynamic process of subject definition. This subject—to cite the title of an important recent exhibition that trenchantly investigated this process of subject construction from an international perspective through works by Raymonde April, Sonia Boyce, Klaus vom Bruch, Miriam Cahn, Francesco Clemente, Antony Gormley, Astrid Klein, Avis Newman, and Jana Sterbek—is in one sense an 'impossible self' (Ferguson and Nairne), since it can never be whole. On the other hand, the seemingly constant attempts by artists and viewers to fix provisionally a point of meaning suggests that there can, even must, be postmodern subjects, and, crucially, that these subjects can have effects.

Thinking back to the topic of Chapter I, memories of art's history, I would argue that the postmodern concern for the subject is part of an obsession with the past as it inflects both the present and future. This new historicist self-consciousness contrasts with central aspects of modernism, instanced here by Mondrian's transcendental aspirations. Should we ever doubt the sharpness (not to suggest simplicity) of this contrast between modern and postmodern memories, we need only recall that

Mondrian's abrogation of the past was subtle in comparison with that sought by two other exemplary modernists, the Futurist F.T. Marinetti and the American abstractionist Barnett Newman. Speaking about the new artist's proper relation to museums, Marinetti wrote in *Le Figaro* (Paris) in February 1909: 'To admire an old picture is to pour our sentiment into a funeral urn instead of hurling it forth in violent gushes of action and productiveness. Will you thus consume your best strength in this useless admiration of the past . . .?' (Chipp, 287). Newman states explicitly that the desire to paint without the past is a desire to avoid memory. In 'creating images whose reality is self-evident,' he wrote in a 1948 article, 'we are freeing ourselves from the impediments of memory, association, nostalgia, legend, myth . . . that have been the devices of Western European painting' (Chipp, 553). Postmodernism in the visual arts, on the other hand, is to a large extent defined by a fixation on the past, a 'past' that is frequently demarcated through the assertion of memory with its concomitant sense of subjecthood defined and redefined by the particularities of context.

Tod's *Approximation* is a difficult work to read. Its luscious surface describes five identifiable forms, each a partial human face, but we are not looking at portraits of the conventional kind. The four large male visages turn out to be 'Toby mugs' or 'jugs', drinking tankards made of pottery that open up the skull in a way that seems quite humorous in comparison with the violations thematized in Ayearst's *Three Minutes* (Plate 1). The smaller, female image near the centre of the canvas is a reproduction of a photograph of the artist Mary Kelly. Why does Tod use images that are themselves already 'taken'—perhaps even 'effracted', burgled, as Derrida suggests in the epigraph above? And why would she arrange these traces in such an optically strenuous way, with most of the faces arranged sideways? What Tod effects here is a distancing from any sense of originality or essential model, a sidelong glance at what she calls 'peripheral emotional states' (1989) whose materialization helps her to define her own evanescent subjecthood and the nature of the subject who creates art. For those familiar with earlier paintings like *Self Portrait* (1982), *Identification/Defacement* (1983), *Self-Portrait as Prostitute* (1983), *My Father, Bob and I* (1983), and *Magic at Sao Paolo* (1985), *Approximation* can be seen as a recent example of Tod's longstanding fascination with the nature of her own selfhood, one she habitually explores through conscious manipulations of memory that create 'impossible' yet revealing situations.[1]

It is worth recalling that we never see our own faces—certainly one of the most potent signs of who we are as subjects—except as they are

reflected optically by a polished surface or a reproductive means like a photograph or painting, or as they are metaphorically reflected in the reactions other people have to us. Thus even though the faces in *Approximation* are not of course reflections of Tod's features, it should not seem unusual to consider them 'hers' while she manipulates them in a project of self-understanding. The narrative Tod constructs for this painting is one of self-identity reconstrued through memory. According to Tod, the Toby jugs are personal artefacts from her grandmother's home in Glasgow, and even to viewers not party to Tod's own interpretation of this painting, they will still be reminders of the British Isles. What Tod recently discovered through a series of family members' reminiscences, however, was that her grandmother wasn't Scottish, even though she lived in Scotland, spoke with a Scots accent, and acquired such typical artefacts; she was also, and somehow more fundamentally, Lithuanian, an emigrant. This sense of national subjecthood changed the way Tod understands her own identity. The mugs, therefore, image the way in which memory's archaeological activity—finding relics from one's genetically determining past—shifts radically as new information is presented. What we construe as history is again inflected by memory. Just as *The Unveiling of the Cornucopia* illustrates the fallacy of art history's assignment of fixed iconographical meaning to the supposed mystery cult at Pompeii, Tod's recollection of the mugs now shows how *false* her previous identification with an assumed Scottish inheritance was.

Her search for her own identity through family history is complicated further by the inclusion here of the Kelly image. The two are not related in blood, yet Tod reports that when she got to know this other woman, Kelly reminded her of her own mother. Kelly becomes an artistic mother, an adopted female progenitor who helps to construct Tod's sense of professional subjecthood. At the same time, there is a link through Kelly to an inheritance over which Tod has no control, her identification with her Lithuanian/Scottish grandmother. Kelly's accent sounds British to Tod, yet she is American by birth. The Kelly 'photograph' is thus fitted into an already complex family lineage. Tod *approximates* Kelly's relationship by inserting her image into the awkward space left after she had painted the mugs. The fit—even after Tod's photo of Kelly has been anamorphically reconstituted in paint—isn't at all exact: on the right edge of the canvas we see a gap. As viewers, we tend to try to 'right' Tod's painting, to turn it so that the four faces are right side up. But Tod thwarts this regularization—this domestication of the subject—with the Kelly image, which can only seem right if the painting stands vertically. There is no stable 'fit', then, no final stasis. What we see is indeed an

approximation—of Kelly, of Tod and her family, and of the mnemonics of subjecthood.

The manipulations of form in *Approximation* are anything but formal, yet Tod does try to make her elements 'fit' in ways we have seen in *Reds on Green*. In a sense, the 1988 painting recalls the Tod of a decade earlier as well as the one of the early 1980s, the Tod who was trying to locate herself in the (largely non-figurative) conventions in which she had been schooled. By disrupting paradigms of vision and conceptualization, both *Approximation* and *Reds on Green* playfully but pointedly blur the perfect edges (whether painterly or psychological) desired by others.

Another of these interruptions in the 'normal' understanding and practice of painting is Tod's self-conscious problematization of what she views as another masculinist inheritance in painting, the emphasis on three-dimensionality. *Approximation* is decidedly matrilineal in its recollections—the grandmother's mugs, Kelly as mother—not least in the sense that it plays with the sculptural forms of the mugs (while luring our attention to them by making their surfaces so beautiful; in other words, as in *Reds on Green* and *Lure*, by alerting us to putatively masculinist practices in order to question them) by denying us as viewers any comfortable vantage from which to see them. Three-dimensionality in painting demonstrates its conventional authority through our desire to see the mugs 'right side up', to have a secure 'perspective', but Tod denies this pleasure and thereby emphasizes the particularity of viewpoint, the off-centre glance. The image that is presented 'correctly' when the painting is vertical is also mediated by that paradigmatic vehicle of the unique viewpoint, anamorphic projection, which can in theory be normalized from only one place. But as with the mugs, any comfortable perception of the sculptural tactility of the Kelly image—any correct point of view, in either the geometrical or the psychological sense—is denied. The usual pairing of anamorphism with 'distortion' assumes the security of a proper angle of reception in comparison with which all others are inferior, but Tod in effect overturns this convention and thus any notion that the Kelly image is either right or wrong. What she thereby projects both materially and metaphorically in this challenging work is the impossibility of having just one stable, guaranteed sense of oneself, of anyone else as subject, of the artist as a uniquely privileged disseminator of meaning, or—finally—of the viewer as a changeless point of interpretation.

Both Tod's reference to Kelly and the technique through which she envisions her are themselves art-historical memories. Both parts of this citation also take us to a crucial reference point in recent theorizing about the construction of the notion of a subject, the psychoanalytic theories of

Jacques Lacan. Not only is Kelly herself interested in his work (Pollock, 162) but, more importantly in this context, Lacan makes the anamorphic image of a skull in Holbein's famous *The Ambassadors* (1533) central to his discussion of what he calls the 'gaze'. This thematic is abundantly present in Tod's image, where the truncated faces in the upper left and lower right—as well as that of Kelly—look pointedly across and out of the image frame. For Lacan, Holbein's Renaissance ambassadors are masters of their world, yet across this portrait of them and their knowledge is projected something alien and at first indecipherable, a shadow or 'scotoma', a cut in the usually homogeneous field of visuality (Lacan, 85–90). Seen from just one point in this visual field, however, this interjected, perplexing anamorphism clearly presents itself as a human skull, a reminder of death and therefore of the ultimate uncontrollability of human affairs. This skull—or any such interjection, like the Kelly image in Tod's 'portrait'—is an instance of the gaze, that already established and active set of perceptual co-ordinates into which any (supposedly individual) subject necessarily places himself or herself in the very act of representation (the artist) or beholding (the viewer). Any artist or any subject of a portrait is thus already seen by the gaze. As Norman Bryson has it, 'between retina and world is inserted a *screen* of signs, a screen consisting of all the multiple discourses on vision built into the social arena' (92). As he goes on to suggest, this screen '*mortifies* sight' (92), since any individual's vision is always already anticipated *and* outlived by the gaze. Tod's memory of Kelly in anamorphic form ties *Approximation* to this further and impersonal constitution of the subject by the gaze, but at the same time the painter's role as an individual subject is not erased because Tod *as subject* also allows this Lacanian memory to obtain in and through her picture. The same delicate economy of subjecthood can be seen in Neil Wedman's startling *Death Ray* (1987; Plate 10).

Wedman's immense and complex drawing articulates in compelling and disturbing ways many aspects of the gaze. Across the image from left to right travels what he describes as a 'shaft of caustic white light' (1987) whose effect is at once somewhat distantly allegorical and violently real. This 'death ray' has its source outside the image, somewhere above the sculpture of Adam (allegorized as Doubt). It then passes over Eve (who represents Certainty as she points to the truth of the written word) and intensifies as it immolates what Wedman deems its 'victim'. Hovering menacingly above this sacrificed body is a Death Angel or 'Death Double', who is the receiver of the victim's spirit. To the left and right of the execution performed by the death ray we see associated tableaux: on the left, an allegorical figure of Madness unveiled, and on the right, two

10 Neil Wedman,
Death Ray (1987)

similarly exposed figures of Crime. Witnessing the entire sacrificial rite is an extensive group of virtues, each of whom—with the notable exception of Hope at the extreme left, who leaves the scene—seems to be approaching the gruesome drama. To the right of Hope, according to Wedman, 'Justice staggers at the base of the stairs next to a hooded, self-protective Temperance, while a knife wielding Charity is restrained by Prudence, followed by Fortitude. Finally there is the double image of Faith, a singular piety divided into two conveyances.' At the bottom of the image is arrayed an eerie collection of quasi-scientific instruments and machines, more witnesses (*vanitas* symbols) to the inevitable passage of life into death. All these elements are contained somewhat uncomfortably in a memorial space reminiscent of a Christian church. Our gaze into this drama—its unveiling—is allowed by the furled curtain at the left.

What we see once this veil has been parted is a singularly rich interpretation of the power of the gaze, the power of vision to create, certainly, but also to destroy (the victim on the altar), to turn people to stone (Wedman's reflection on the Medusa theme), to compel our attention and also to repel us morally. What Wedman terms 'Death Ray Consciousness', a concomitant of the long-standing fascination with the 'Evil Eye', is a mixture of 'dread and desire'. He is concerned with this reciprocal power of vision as explained by the philosopher Boethius (480-524 A.D.), who wrote that 'sight is common to all mortals, but whether it results from images coming to the eye or from rays sent out to the object of sight is doubtful' (1987). The gaze, then—and here we can also return to the Lacanian context[2]—is a bi-directional projection: it can emanate from an artist or viewer, but it is also independent. For Lacan especially, as we saw with the skull in the Holbein example, this uncontrolled gaze *at us* is deathly; it obliterates the unified subject. Wedman's image of the death ray illustrates this deadly power. The subject is projected by the gaze; the gaze can in turn be projected by the subject. What we can take from this work is his profound reflection on the creation of this volatile subject—whether artist or viewer—through the *collusion* with the gaze, a collusion acted out in *Death Ray* by the witnesses and enacted by Wedman and his audience in viewing this spectacle of horror.

Wedman's memories are art historical and occult. His vision and technique are today anachronistic: he recalls systems of allegory, a papal tomb for the victim's pedestal, and, in the face of the figure of Crime, Hogarth's depiction of Tom Nero in *The Four Stages of Cruelty*. His technique—graphite and linseed oil applied on primed, stretched linen—itself gives a sense of pastness to his images and is consciously disruptive of any clean distinction between drawing and painting. Wedman's melding of his

sources and inspirations is also not seamless. As we come close to his huge drawing, the 4-foot-square sheets of paper devolve into individual sections reminiscent of Wedman's copious studies, drawings that are, as John Bentley Mays has astutely pointed out in a review of *Death Ray*, 'a field for working out and trying artistic ideas'.[3] In this way these units and the work as a whole resemble an archaeological reconstitution reminiscent— in the context of this book—of General Idea's *Unveiling of the Cornucopia*. All these memories function, in his words, as 'social allegory and as social self-admonishment for the insoluble predicament'. I want to suggest that this 'predicament' is both that of the gaze—its power over us and its attendant destructiveness—*and* that of postmodernism's complicit critique, the impossibility of disengaging 'objectively' from the objects under scrutiny. Wedman uses anachronism without any touch of nostalgia; he doesn't return us to a mystery cult but rather mirrors it for us in order to force a moral confrontation, to make us define our subjecthood in light of the annihilations of the gaze. Just as Perseus employed his mirror-like shield to slay the Medusa, whose countenance and Evil Eye could kill when looked upon directly, Wedman partially deflects the murderous potential of the gaze by reflecting on it historically in *Death Ray*. We are compelled to look at this scene and to recognize our self-definition and complicity in the act of looking.

Like so much reflection on the past, *Death Ray* is finally oriented towards the understanding of the artist and observer as subject in the future. If we focus for a moment on Wedman's Angel of Death, we notice that he has the highest and most inclusive vantage point of the figures within *Death Ray*. He surveys the enclosed space and its inhabitants at what seems the very moment of death, the moment when the victim is only partially (though decisively) vaporized by the Death Ray. It is an instant of moral judgement, as the relief just below and to the left of the angel showing Adam and Eve expelled from the garden would suggest. Describing Paul Klee's painting *Angelus Novus*, Walter Benjamin captures the apocalyptic nature of the Death Angel and his relation to the past in a manner that powerfully evokes Wedman's work:

> [Klee's image] shows an angel looking as though he is about to move away from something he is fixedly contemplating. His eyes are staring, his mouth is open, his wings are spread. This is how one pictures the angel of history. His face is turned toward the past. Where we perceive a chain of events, he sees one single catastrophe which keeps piling wreckage upon wreckage and hurls it in front of his feet. The angel would like to stay, awaken the dead, and make whole what has been smashed. But a storm is blowing from Paradise; it has got caught in his wings with such violence

that the angel can no longer close them. This storm irresistibly propels him into the future to which his back is turned, while the pile of debris before him grows skyward. This storm is what we call progress. (257-8)

Benjamin's storm could also be likened to the gaze, which travels through history, as Wedman shows us. In effect, the angel in *Death Ray* mirrors the gaze just as Perseus mirrored Medusa's countenance while keeping his back to her. As Benjamin suggests, this is how subjects must 'face' their future, propelled by the debris of history and memory, partly subject to the gaze they cannot always see but also using its power.

Wedman's exhibition and drawing called *Margery* (1990)[4] continue to explore the intersection of the gaze, moral responsibility, and the evanescent nature of the subject. *Margery* enigmatically and compellingly pictures a woman confined in a desk-like box with only her arms and head free. On both her left and right sit three men, each of whom directs his gaze at the woman named Margery. The entire group forms a semi-circle with joined hands. In conversation Wedman has said that Margery was a noted medium who is here shown conducting a seance in an attempt to prove the possibility of the spirit world by escaping from a very confining contraption designed by none other than Houdini, who strenuously fought against the idea of spiritual transport. Margery herself is three times trapped by the gaze: she is physically confined by the overpowering conventions of scientific proof that occasioned this experiment, she is trapped by the individual stares of the six men attending this seance, and she is projected (and subjected) by the gaze of artist and viewer alike. Her subjecthood, then, is defined by the co-ordinates of the gaze, co-ordinates that Wedman presents—not without self-conscious complicity—to our judgement.

Marcel Gosselin's whimsical sculptural obelisk entitled *The Observatory* (1986; Plate 11) might at first seem very removed from the concerns of *Death Ray*. Yet what Gosselin constructs is a lighter but no less significant rumination on the gaze. *The Observatory* is very literally a memory machine. Since this sculpture is designed to capture the chance appearance of a fleck of dust as it crosses a ray of light, its aleatory operations are likened by Gosselin to the workings of our memories as we construct our own identities by catching, and reflecting upon, certain fragments of existence. The principle of the memory chamber is illustrated in Gosselin's working diagrams for this sculpture, where we see a shaft of light entering from the slit in the top of the sculpture. A viewer's gaze is directed across this beam by the placement of the T-shaped opening in the side of the piece. It is important to know that *The Observatory* was but one of a

11 Marcel Gosselin,
The Observatory (1986)

large number of sculptures collected together by Gosselin into what could best be described as a dramatic vision of memory's role in the making and perceiving of art, his *Delta* exhibition at the Winnipeg Art Gallery in 1986. As one of these diagrams shows, these sculptures formed part of an elaborate fictive world created by 'the man in white' and seen by a 'Visitor'. Both men's responses to the sculptures are remembered by Gosselin in two poetically evocative texts—each presented by the author in French and English versions—one by the Visitor, the other by the man in white, who made the sculptures, at least in the material sense.

The man in white's recollection of *The Observatory* reads as follows:

> One day, right before my eyes, in a space closed and dark, a space where I hid, I saw a floating shape. Infinitely small and brilliant, it spun and flipped around in the air when I blew on it. I could see nothing but this anonymous shape and the pin hole from which came the light that illuminated it, each a star in the depths of my dark space. But this was not, like a star, a perfect dot. It was rather like a bright scratch on black paper. Dishevelled by its voyages through the wind's folly, it looked like a ruffled thread-end discarded because it refused to pass through the eye of a needle.
>
> Within my enclosure, seated before this floating point, my thoughts expanded. The ray by itself was invisible, as was the speck of dust. Together they were fulfilled, depending one on the other and I on both of them. We were three: an eye on the dust in a ray of light—an audience watching a showman in a spotlight.
>
> I built a stage for it. A stopover where unknown particles, followers of fate, will find a moment of glory, perhaps.
>
> If only an eye would see. (*Delta*, 51)

The Observatory celebrates the positive, enabling work of the gaze: it is a 'life ray' in this account. But like Wedman, Gosselin also emphasizes how the ray constructs its observers' subjecthood, how our chance encounters with its activities are constitutive of our own memories. More than Wedman, Gosselin underlines the *spatial* particularity of memory, how one's body must adopt the right attitude in order to see into the observatory. As he reports with respect to more recent work, his 'alloying' of materials and circumstances helps him to 'contemplate the flow of things from past to present', their passage through his own artistic agency ('Statement').

Gosselin's *Fragments* exhibition at Mercer Union in Toronto in the fall of 1989 exemplifies this tendency in his work. The artist collected and presented an idiosyncratic archive composed of his written thoughts (which again accompany the objects, as in *Delta*) and artefacts found and recomposed in his immediate environment. His objects and ideas are at

once intimate and strange. In the catalogue he writes: 'These pages are fragments of my thoughts alloyed with a world I know little about, even though we have been collaborators for as long as I can remember. I contemplate our assemblages and sometimes, when the winds are right, they reveal to me a bit of their mystery.'[5] We may extrapolate from this to suggest that memory itself is the observatory, the trap for the particles or fragments of experience out of which we build a past and a future. Memory, Gosselin believes, is all you have, and *The Observatory*, like its cohorts in *Delta* and *Fragments*, seeks to forestall forgetfulness.

Gosselin's recollection of fragments in an ongoing project of exploration and subjective definition is anything but an isolated phenomenon in postmodern art. It is symptomatic, though inflected with an unusually sanguine and almost shamanistic belief in art's therapeutic possibilities. Analogous in many ways is *Le Musée des Traces* (1989) by Montréal artist Irene F. Whittome, in which a range of personally significant objects is collected and displayed photographically (mostly) in a museum-like space that recalls the eighteenth-century Cabinet de Curiosités[6] but that also remains open to change through visitors' eyes. More psychological and disturbing is the installation *Fear of Memory* (1990; Plate 12) by the London, Ontario, photographer and filmmaker Wyn Geleynse.

Fear of Memory is a complex installation comprised of thirteen modified 'Showbeam' toy projectors mounted on stands and projecting their single images onto page-like sheets of glass. Because of the lightness of the apparatus, the projected images move slightly, and their tentativeness is further heightened by the fact that Geleynse has ground the glass where the images appear, giving each picture a soft, blurred quality. Each fragmentary picture is quite banal in itself: we see a hand reading Braille, another holding a knife, another caressing a photograph. Entering the semi-circular space defined by these projections, however, the viewer finds that the fragments trigger memories and associations that—at least temporarily—coalesce into narratives. What Geleynse identifies as two types of memory work together here. We freely choose to look at his work, to remember, but recollections also arise unbidden. Here lies the fear of memory, the inability to forget and the impossibility of controlling exactly what will be recalled.

Geleynse focuses his viewers on the exchange value of images and disputes any intimation of an integral meaning. Just as when any of us shows a picture of a loved one, for example, to someone else, *Fear of Memory* constructs a social situation in which both artist's and viewer's sense of their own subjecthood is constantly redefined mnemonically by the activity of framing the fragment, by what is edited out (and by whom)

12 Wyn Geleynse,
Fear of Memory (1990; installation view)

as much as by what is literally visible. In exploring the exchange system of memory, Geleynse simultaneously questions the often troubling psychology of remembering, its characteristic projection and editing.

He has been working in this realm throughout the 1980s. In *Portrait of My Father* (1982), for example, he examines his relationship with his then aging father through a comparison of images, the fragile older man and the strong young son who takes his place in the piece, both filmically and figuratively. We see a large still photo of Geleynse holding a smaller 'photo' onto which is projected a film-loop image of his father sitting in a chair. For whose understanding, whose memory, does the son present the father? It is the younger Geleynse who exposes himself psychologically by materializing his memories. The same is true in *Remembering* (1984), where a film loop showing a crucial site recalled from Geleynse's childhood—a small bridge in Rotterdam—seems tentative and uncircumstantial compared with the nostalgia it evokes in the artist, a nostalgia reinforced by the work's installation on a ledge, the sort of place one would place important photos in one's home. Again, he reveals and defines his own subjecthood through such recollections. That these fragments are not in themselves changeless relics from the past, *not*—as Roland Barthes romantically construes them—simply 'emanation[s] of the referent' determined by light (*Camera*, 80), is argued in another memory piece, a reflection on Geleynse's mother called *We Never Knew Her Past, Than Through Her Photos* (1984). Looking into one of a row of five old Brownie Hawkeye cameras, we see an image of Geleynse's mother that he could not have experienced except through the purposeful recollection of a photo, since he wasn't born at the time they were taken; as Barthes suggests in writing about a similar experience, 'no anamnesis could ever make me glimpse this time' (*Camera*, 65). Yet Geleynse suggests here that memory in fact *does* construct reality for us (as he has done with his own mother's past), that it is all we have and no less real for its mediated quality, perhaps especially with respect to a time out of which we are necessarily edited yet into which we necessarily project, a time that is our inheritance. As in *Portrait of My Father*, the 'real' photographic process is reversed. The son tries to understand himself by re-taking photos that were not about him, by reframing and reanimating them. Again, the revelation here is of the artist: these are self portraits, as is *Fear of Memory* in many ways, and what Geleynse constantly confronts is both the quirky psychology and ethics of memory and its representation.

Critics of note both in Canada and abroad have identified a fascination with technology and media as typical of recent Canadian art. Bruce Ferguson (in the catalogue *On Track: An Exhibition of Art in Technology* that

was part of the Olympic Arts Festival held in Calgary in 1988) cites technology as a 'predominant value' (3) and goes on to discuss the work of two artists included in this book, Geleynse and Barbara Steinman. The Cologne art critic Noemi Smolik claims in a review of Canadian art at the 1986 Cologne International Art Market that an 'intense preoccupation with mass communications methods' is one of three features that distinguish contemporary Canadian art (the other two are the predominance of women artists and themes and the continuing importance of landscape imagery [93]). These observations can readily be attested in a general sense, and even if we narrow down the concerns for technology and mass communications to those mnemic elements directed towards an investigation of the nature of the subject, important examples come to mind. We have already seen Geleynse's concern for the technologies of image production as well as Murray Favro's seminal *Van Gogh's Room*, a work that Geleynse acknowledges as a major influence. In video, Tom Sherman's 1987 *Exclusive Memory* establishes what Peggy Gale has aptly called 'a veritable ethics of memory' (24). In this 182-minute tape, we see Sherman discoursing on a variety of themes. He seems to be addressing the viewer, but the narrative reveals that he directs his speech to a 'robot', an unseen (video) machine without memory (which is nonetheless able to record) that he is trying to teach. Are we as viewers also posited as forgetful machines who must have our memories—our sense of ourselves as existing over time—constantly restored? Looking back to Canadian art of the 1970s, we can see that memory and technologies (though not always the most advanced) were brought together to define the subject in Jack Chambers's ground-breaking film *The Hart of London* (1968-70)—in which he attempts to exorcise his feelings for London, Ontario—and in Ian Carr-Harris's *Nancy Higginson, 1949-* (1972), to cite only two prominent cases. Carr-Harris 'defines' this woman through a primitive memory system, the card catalogue, a textual archive in which the photo of Higginson seems out of place, dominated as it (and so much of our lives) is by language. Of course this emphasis on the nature of subjecthood is not uniquely Canadian—think of American Cindy Sherman's posed 'self' portraits, which investigate conventionalized possibilities of the feminine, or French photographer Christian Boltanski's various 'monuments', which collect photos and other memorabilia into powerfully evocative interrogations of the status of the past—but because of its prevalence here and the penchant of technologies and media to control memory and the subjects they address/define, it should not be surprising that so many memory works have this focal point.

One of the most overt memory works recently produced in Canada

also engages with the construction of the subject: Janice Gurney's *Screen* (1986; Plate 13). Out from the middle of its three panels a young woman holding an infant stares imploringly. She is framed on the left and right by two out-of-focus images across which a text, from a poem by Marguerite Duras called 'The Lover', runs in red letters. This text itself frames memories, but they are difficult to decipher, since if we read the words on the left panel, for example, the text remains fragmentary:

> At the time she'd
> thirty-eight. And the
> ten. And now, when
> she's sixteen.

We realize even in reading this way that time has elapsed, that we are in the presence of someone's recollection. But in order for this text to read more 'normally', we must join it to the lines on the right:

> At that time she'd / time she'd just turned
> thirty-eight. And the / And the child was
> ten. And now, when / now, when she remembers
> she's sixteen. / she's sixteen.

Without Gurney's fragmentation, this recollection would read:

> At that time she'd just turned
> thirty-eight. And the child was
> ten. And now, when she remembers
> she's sixteen.

The ambiguity of this narration, however, is not at all decreased by such manipulations. It is very difficult to say who is speaking, whose memory this is, especially when we add to the text the important fact that we must read it literally over the bodies of the two figures in the central panel, thus somehow applying the text to one or both of them. We could understand the memory to belong to the woman holding the baby as she looks back at herself at age thirty-eight, her child now ten. But if we define these two people this way, the numbers don't add up: if the child is ten and the woman thirty-eight, the woman bore her baby at age twenty-eight, not 'sixteen', as the next line seems to suggest. Perhaps the 'she's sixteen' refers not to the older woman but to the child at another age. But we don't and can't know. In fact, we don't even know the gender of the child.

Screen projects both the power and the instability of memory. It is only through recollection that we can have a self either past or present, yet this self is anything but unitary, as the construction of this work makes clear.

13 Janice Gurney,
Screen (1986)

Gurney presents the selves of the text at various ages, and she shows us two people. These figures, however, are not necessarily the subjects of the text, since they are reproductions of a still from Erich von Stroheim's film *Foolish Wives*. The filmic, kinetic quality of *Screen* is doubled by the title (as in movie screen) and by its physical separation into 'frames', as well as by this historical allusion. And there are many doublings of material. The film clip is reproduced as a photostat, for example, and the border at the bottom (where we might expect to find a text) is a photographic reproduction of canvas, the painter's traditional support. Finally, Gurney's purposeful layering of materials—with plexiglass on top—causes us to see reflections of ourselves and our immediate context. Viewers' memories ('reflections') are thus caught in the screen too. Very likely, if we are at all influenced by Gurney's text, we will project what Freud calls 'screen memories', a significant type of 'recollection . . . whose value lies in the fact that it represents in the memory impressions and thoughts of a later date' that are nonetheless *attributed* to childhood (Freud, 'Screen Memories', 123). As Freud sees it, these memories are not actually of childhood experiences, but the rememberer thinks they are. The notion of screen memory thus underlines the importance of childhood as a mnemic locale (since we typically feel that these supposedly early memories are fundamental, as I have already suggested with respect to Geleynse's *Remembering*) and also the fact that memory can happen only in a subject's present. In Gurney's text, a woman recalls when 'she's sixteen': but who was sixteen? To whom do these childhood memories belong? The woman in the film clip looks sixteen, but if this subject, this 'she', is now the focus, *Screen* actually generates more gaps that it fills. The enigmatic yet essential processes of forming a subject are thematized throughout Gurney's work, as we will see further in Chapter III.

With Freud now figuring in our discussion of this work, it is appropriate to return to memory's essential double, forgetting, and to one of its chief mechanisms in Freudian psychoanalysis, repression. I want to discuss this notion in the context of a Freudian idea that seems highly applicable to *Screen*'s exploration of subjecthood and to the concern for related issues in Alice Mansell's *Manoeuvre* (1986; Plate 14) and in *Basel* (1986; Plate 15) by Angela Grauerholz: the *unheimliche*, the 'uncanny'. Freud's 1919 essay on the phenomenon of the uncanny turns on the proposition that these strange and frightening experiences result from confrontations not with the unfamiliar—as common sense might suggest—but with the return of explicitly familiar 'childhood' experiences that have been repressed. The uncanny, he argues, is 'nothing new or alien, but something which is familiar and old-established in the mind and

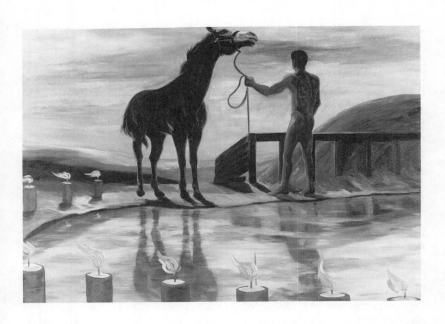

14 Alice Mansell,
Manoeuvre (1986)

which has become alienated from it only through the process of repression' ('Uncanny', 363–4). I want to suggest that the uncanny is thus closely related to screen memories, since both deal with memories attributed to childhood that interject themselves at a later time. One source of the uncanny for Freud was the experience of what he called the double, and as we have seen, doubling is screened on many planes by Gurney. Citing Otto Rank's 1914 study of the double, Freud claims that the following experiences can occasion the uncanny: 'the connections which the "double" has with reflections in mirrors, with shadows, with guardian spirits, with the belief in the soul and with the fear of death' ('Uncanny', 356). Just as repression—a species of forgetting—defends the psyche in Freud's thinking, so too he sees the phenomenon of doubling as protective of the formation of the subject. Doubling, he claims in a rather obscure passage, is 'an urge towards defence which has caused the ego to project . . . material outward as something foreign to itself' (358). Here we have the pattern of the screen memory, the projection of a later experience onto childhood. The result, as we see in *Screen*, is an uncanny doubling, a doubling ultimately of different yet continuous subjects over time ('she' was thirty-eight and sixteen) that is signalled in this work by the repetition of words as we read from left to right across the woman and child. Freud's repressed content does indeed return through memory, but it is never finally resolved in Gurney's typically postmodern exploration of the multivalent subject(s) in *Screen*.

Alice Mansell's *Manoeuvre* plays with notions of doubling and the defamiliarization of the commonplace in ways that can also be described as uncanny. The familiarity of each element in this work is crucial to Mansell's exploration of her own sense of subjecthood and place, her own inheritance. The prairie landscape with its part natural, part cultural earth mound, the horse, the fence, the naked male torso as a classical image of aesthetic beauty, the pond, the candles—individually, none of these memories is odd or troubling. Yet their combination and repetition has an unsettling effect. It appears that the man is trying to lead the horse into the circle of fire that the candles form, and that the horse resists. In addition, the horse and man seem somehow generic, especially when we look to their doubled reflections in the foreground, which are indistinct and decapitated. Two other types of doubling illuminate what thus turns out to be the allegory—itself a form of repetition—that Mansell paints. Her very personal reflections on her western background are combined with a conscious allusion to Jacques Louis David's *Oath of the Horatii* (1784), since she has used (and partially diffused by reversing the image and easing its corporeal tension) his dramatic and distinctly masculine image of oath-

taking to visualize the man leading the horse. In David's famous canvas, the three Horatii brothers raise their arms and bring their weapons together in a focused and charged moment of mental and physical resolve, while the members of the contrasting group of women to their extreme right sink physically into grief. Mansell's male figure is a much-altered reflection of and on David's image of bellicose comradery. He tries—but seems unable—to lead the horse, somewhat like the charioteer (Reason) in Plato's *Phaedrus*, who has difficulty controlling his horses (Passion). Just as the pond in this image partially reflects yet alters and suggests further ambiguities about its 'originals', Mansell's reference to David is not a reverential memorial. Her citational doubling screens questions about the nature of feminine subjects in general—as they are constructed by and related to art's own past—over images of individual subjectivity.

The title is itself a bilingual pun that directs us to the imperatives of man's work (*oeuvre*) in art. We can also hear a reference to painting and its purportedly masculinist traditions in the layering of implication suggested by the cross-lingual homonymity of '*main*', French for 'hand', and '*oeuvre*': the hand's work, painting. The uncanniness pictured by this work offers resistance to what Mansell envisions as the masculinist control of painting. She effectively refuses the conventions of traditional painting in order to explore her own subjecthood and to speculate on the nature of femininity in art practice.

Montréal artist Angela Grauerholz's photograph *Basel* (Plate 15) presents another instance of the uncanny, of familiar sights like a back street and rushing water combined to form an improbable image with the potential to unsettle us. This odd event is captured in such an unobtrusive and calm way as to seem almost whimsical. How can so much water be in what seems like the wrong place, and in Switzerland? What is potentially frightening is not the water itself but the ability of the camera to make it look so beautiful, to normalize it. And who is the subject or viewer behind the lens, who is the normalizer? *Basel* captures two elusive qualities of memory that precipitate such questions, its 'aura', and its 'atmosphere' (Casey, 76-8), and both of these aspects work against the still common opinion that a photograph is simply a reminder of a circumscribed, past event.

When we remember, our recollection is not encased in an impermeable, clean-edged frame. As I suggested with respect to Wyn Geleynse's installations, it runs out into other memories and imaginings: the aura, according to Casey's insightful phenomenological account, is that which a memory dissolves into (77), what we might call its ambient context. The qualities of an aura will thus depend entirely on each instance of recall and

15 Angela Grauerholz,
Basel (1986)

upon each rememberer. In *Basel*, the enigmatic image diffuses into circumstances that could explain the image and that inevitably go beyond its material edges. We want to know who took the picture and why, in order to fix its meaning. The uncanniness of this photograph provides this quality of aura, but it denies us *an* association, *a* source for the image. We are thrown back to what the photograph presents visually, the 'atmosphere . . . experienced as pervading the presentation itself' (Casey, 78). How can we define this atmosphere? The softness of the forms resulting from Grauerholz's long exposure time seems at first to work against what we realize is a turbulent rush of water. But what the passing water and exposure have in common is duration, existence over time, and duration at least partially infuses the image. Grauerholz has managed the improbable (uncanny) feat of showing time in space, and I would like to suggest that this presentation of the seemingly unpresentable through a memory image is a contemporary replication of what is at best a distant recollection for some artists today, the category of the sublime.

Basel's mnemonic atmosphere—which is to say, the mode of its presentation, its ability to present that which seems unpresentable, not the object or event shown—is sublime. In a sense this picture recalls the historical sublime by combining potential danger with aesthetic control, but we do not see the typical objects of the sublime as found in eighteenth- and nineteenth-century paintings, like mountains, storms, or the sea in its vastness. To use Peter de Bolla's distinction, Grauerholz's is not so much a discourse *on* the sublime—its historical manifestations—as a discourse *of* the sublime, 'which produces, from within itself, what is habitually termed the category of the sublime and in doing so . . . becomes a self-transforming discourse' (12). But what is the status today of a category that so completely defines itself by mastery, the sublime's (and art's) mastery of the inexplicable and unrepresentable? Even though *Basel* generates references to the sublime in its play with time, its sublime atmosphere is decidedly postmodern, which may well imply—as Chantal Pontbriand has hinted (16)—that it is an anti-sublime. Jean-François Lyotard's pronouncement on the recent rekindling of interest in the sublime applies well to *Basel*. 'The postmodern', he writes, 'would be that which . . . searches for new presentations, not in order to enjoy them but in order to impart a stronger sense of the unpresentable' (81). Similarly, the postmodern subject(s) implied but not defined in this photograph find evanescent subjecthood in the constantly renewed processes of memory work.

Other photographs by Grauerholz memorialize while questioning the sublime and, by implication, a contemporary photographer's relation to

this painterly and literary tradition. In 1987, two black and white images referred to icons of the sublime: *Mountain* to one of its prime exemplars in nature, and *Landscape*—with its *Vanitas* tree stump—to the inevitable passage of time and regenerative power of nature so often thematized in Dutch seventeenth-century landscapes. Grauerholz reaches again for the generic with *Clouds* (1988), a sepia photograph taken into the light in which the vastness and incomprehensibility of the sky is dramatized.[7] Memories of the sublime are so common a site for the redefinition of the contemporary artist-as-subject that they are, I believe, becoming a genre. Paterson Ewen's powerful 'phenomenascapes' recall Turner; Wanda Koop's vast images from the mid-1980s—like *Airplane* (1983)—present very personal feelings and recollections on an overpowering scale, and Jocelyn Gasse's sculpture entitled *Composition No. 104* (1986) presents mysterious ascending volumes reminiscent of another of the historical sublime's central motifs, the waterfall.[8]

The two remaining works to be examined in this chapter explore the interrelationships among memory, time, space, and the subject's identity through the technologies made available in large installations. Memory, by definition, involves time, and the interconnections between these two categories with regard to their spatialization are revealed tellingly by Sylvie Bélanger's *Essai de Synthèse* (1990; Plate 16). As her title suggests, Bélanger's work is highly textual, not just in the sense that, like so many of the works here, it displays the written word, but in the broader sense that whatever 'reality' we can know can only be known in a mediated way—in this context, through memory. The dark green space we enter in this work (the first time Bélanger has essayed the use of colour on this scale) is a technologically filtered and orchestrated reflection of a sacred space. The green recalls Bélanger's discovery of painted columns in a Dutch church and the windows remind us of gothic interiors. Architectural details thus bespeak the past, but it is a past screened by the artist's memory, since Dutch church interiors are not all green and gothic windows don't have this exact appearance or scale. Yet again, we have entered a memory space where the past is brought forward.

The six windows frame light boxes whose transparencies are like stained glass. What we see, however, are split images—double memories—of cities, a view on top and a plan below. We could never have these views *out* the windows; the information is beamed in. Each window places the viewer corporeally—'you are here'—with a legend tying plan to view. Yet each window is different. To compound the malleability of memory that is presented, none of the images of cities we see is 'real': each has been taken from a historical document and regenerated by a computer.

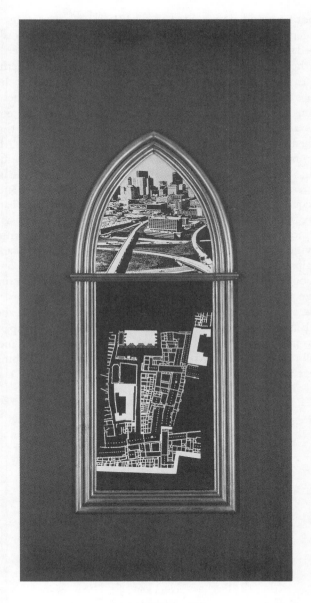

16 Sylvie Bélanger,
one element from *Essai de Synthèse* (1990)

We do not know where we are at all, and Bélanger's work suggests that maps' legends are never as useful as they claim to be. We *do* know that we are located spatially as well as temporally, though, since the letters she uses to link the upper and lower images in each window together spell S.P.A.C.E. The duration necessary to perceive this text, however, reinscribes the importance of time in memory. What Bélanger describes as the 'collapse of traditional temporal structures of past, present, and future' (1988) is also experienced as we look at the video screen that stares unexpectedly—since we have just oriented ourselves to the 'Medieval' light coming in through the windows—up at us from the floor. It is located in a mandala engraved on slate and as such recollects the labyrinth at Chartres cathedral, the most famous instance of Gothic. Such labyrinths frequently held at their centres some identification of the cathedral's author(s), but this information is missing at Chartres (what was likely a bronze plaque is gone). What the *Essai* substitutes for this identification is a short video loop. Modern technology recalls but decentres any stable authorship, subjecthood, and authority.

The loop again emphasizes temporality. If we think of it as a single eye, the image is at first unfocused. Fragments seem to fly towards the six apertures, suggesting a competition between sources of light and information. But as the video's light intensifies, a textual image (the past itself?) begins to gel, just as the spatial subject is localized and then moves on. Eventually we are able to read the following words by French thinker Paul Virilio as they scroll by:

> We've passed from
> the extended time of
> centuries and from
> the chronology of
> history to a time
> that will continue
> to grow ever more
> intensive: we live
> in a world of
> intensely tiny units
> of time. The real world
> and our image of the
> world no longer
> coincide.

This text then moves off into deep space in a block (playfully) reminiscent of the famous prologues to the *Star Wars* movies.

Technology seems to tell us that time is changing, that we can no longer be assured of its continuity in spite of the growing intensity of the temporal in our lives. The 'intensely tiny units' are focused in and by each viewer/rememberer. This is an existential time, not the blithely purposive teleological time of 'real' history. We must and do place ourselves in time, but not securely. The *Essai*—in concert with Bélanger's previous work, like the installation *Triptych* (1988), and with General Idea's *Unveiling* (Plate 2)—challenges the verities of archaeological or art-historical 'digging' by reconfiguring technologically the cities we see through the windows. The past is here, just as it is in the gothic forms that surround us, but it is a projected past, a past that constantly reforms—and is in turn reformed by—its subjects.

Vern Hume's *Lamented Moments/Desired Objects* (1988; Plate 17) presents us with a space very different from that of the *Essai*: a domestic space, a living room in which we are encouraged to reflect on childhood experiences and the modes of their conveyance from the past into the present. A comfortable chair invites us to watch the video in which Hume ingeniously constructs a sense of self—though not necessarily an autobiography—from fragments of home movies of his own childhood, pieces that are crucially reinforced and questioned by the other elements in his installation. He is fascinated by how we as subjects are 'fixed' by these images and the sounds and narration that accompany them, and by how these definitions are simultaneously unrepresentative of our sense of self—how, for example, the home movies show people 'perpetually on holiday'.[9] The reification characteristic even of these moving images is duplicated by the more literally 'fixed' pictures (stills) that hang as reminders around the living room. The text provided by Hume is another point of reference, another memory frame, as is the child's wading pool with its attendant projected texts, taken from the video's narration. Unlike the uncanny images we have just considered, *Lamented Moments/Desired Objects* is decidedly homelike, purposefully familiar. We are in a sense put inside a life, inside a network of memory with its rich, mnemonic intricacy. We can see these memories, hear them, and feel their textures. Hume allows us to understand memory's work phenomenologically, to appreciate the multifarious ways in which '*we are what we remember ourselves to be*' (Casey, 290).

The range of technologies operating in this piece mimics the variety of mnemonic sources with which we work to inscribe and reinscribe our sense of self. The visual is of course crucial, and in what we might call the prologue to the video, a short sequence that runs before the title appears, Hume's narrator describes a visual scene that is 'fixed', which 'never

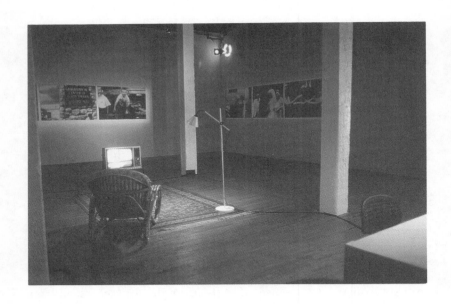

17 Vern Hume,
Lamented Moments/Desired Objects (1988; installation view)

changes'. It is a specular, mnemonic anchor somewhere in the past. His 'archival' family movies provide the initial triggers for these recollections, but the return is never simply to a past that is distinct from the present. Hume intermixes old footage from his family with newly-shot images *of* these memories, thus literalizing and envisioning the process of overlay—the constant revision of memories as they are replayed—that typifies recall. The narrator remarks on the peculiarity of 'glances back with foreknowledge', of 'a conscious gaze directed back', or—in a phrase that captures the paradoxical temporal orientation of memory—of being 'future voyeurs in their own past'. Whose gaze is this? Sometimes it can be identified as 'myself returning my own gaze', a match between the younger and older Hume, perhaps. But more often there are gaps, strange inconsistencies that make the remembering of a subject elusive, if none-theless necessary.

This elusiveness is most noticeable in the non-visual memories so brilliantly captured in this work. The soundtrack is replete with aural recollections—footsteps on gravel, for instance—that betoken with their cadence and purposefulness the presence of a person. Recalling a fleeting experience of walking onto grass in bare feet, the narrator reports that 'cool feet sent shivers up my spine. There are no shots of this.' Visual cues, technological supports, are not directly responsible for this type of body memory. Nor is the visual central to what we might call textual, narrated memories, the ones that Hume shows to be the most disembodied, the most foreign, even though we are told that the past they describe is 'ours'. Just after the first fleeting image of the wedding appears on the screen (an image that is fixed for us in the stills on the wall), the speaker gently intones: 'Events forgotten, now images, saved. Evidence of the real past, now a fiction narrated as disconnected stories from another's life.' These are the memories in which others tell us how we were, tell for us. They are communal screen memories in the Freudian sense, since other adults have them *for us*, in our childhood. 'I participate in this scene,' the narrator muses, 'but I have no real memory of it.'

What, then, constitutes a 'real' memory and a 'real' past? The evidence of photography—moving or still—has to be reckoned with, but it isn't infallible. *Lamented Moments/Desired Objects* underlines with the slippages between the different modes of recall the undecidability characteristic of memory. The voice we hear doesn't always describe the scenes we watch. At one point—right after we hear about the shivers caused by the cool grass—the image breaks down completely for a few seconds. Yet Hume's title helps us to negotiate the enigmas of memory that he enacts. The fragmentary nature of all aspects of the installation suggests that

'moments' of what memory makes past are all we have. Because of this manifest incompleteness, we are frequently nostalgic for the sense of a whole past (and therefore present) that seems to be promised by the missing information held, we hope, in the interstices between recollections. As Plato claims in the first epigraph to this chapter, desire leads us back, desire for history, for continuity, for a stable subjecthood. But what we have—a postmodern artist might respond—is the process of memory; images are 'fixed', but only to be revised constantly.

Hume's project at first seems to be one of self-absorption, but his scrupulous avoidance of autobiography—even while he uses material from his own memories and those recorded by his family—alerts us to a more extensive purpose. Each viewer is (supposed to be) inspired by what amounts to a focused recollection of subject-construction through memory to replay his or her own past. As *Lamented Moments/Desired Objects* illustrates, this past cannot be merely individual; memories are not in any simple sense 'ours'. And this collective quality is, for Hume, the key to a sense of subjecthood on a more regional scale. Writing about the cultural marginalization of western Canada, he argues that 'there has been no collective memory to keep alive the knowledge and experience [that connect] the present to the past. A fracture, a loss of memory and history, has occurred' (6). His remedy for this amnesia is not to propose total recall through mnemic introspection. Forgetting is a crucial part of what we remember. What he seeks instead—and I think this work represents the beginning of an answer—is the ability to place 'identity', to find and recast the continuity among the memories. 'To exist and continue, a community must be able to recognize itself, thus constructing its identity rather than accepting the identity imposed from outside' (6). As an exploration of the personal dimensions of this recognition, *Lamented Moments/Desired Objects* is a step towards a more sweeping projection of communal recollection and action.

If memory and its correlatives, forgetting and repression, can be understood as processes and even as locales through and in which the nature of the subject is continually forged in the contemporary Canadian art we have been considering, then we need to ask in what ways this subjecthood should be called postmodern. Clearly, earlier artists and discourses about art have challenged the humanist notion of a unified and self-transparent subject as the source of creativity. The aleatory experiments of Hans Arp within the Dada context would be one example. But not until much more recently has there been such a sustained scepticism, both within and without strictly artistic contexts, about the subject-as-artist. Michel

Foucault has been responsible for much of this de-centring. The challenge he outlined in *The Archaeology of Knowledge* (1969) remains with us:

> instead of referring back to *the* synthesis or *the* unifying function of *a* subject, the various enunciative modalities manifest his dispersion. To the various statuses, the various sites, the various positions that he can occupy or be given when making a discourse. To the discontinuity of the planes from which he speaks. And if these planes are linked by a system of relations, this system is not established by the synthetic activity of a consciousness identical with itself, dumb and anterior to all speech, but by the specificity of a discursive practice. . . . it must now be recognized that it is neither by recourse to a transcendental subject nor by recourse to a psychological subjectivity that the regulation of [the subject's] enunciations should be defined. (54–5)

The memory works with which we have been engaged—with what I hope is an appropriate specificity—do indeed question the subject in just these ways; they are parallel enactments (not effects) of what Foucault has himself practised in his studies of Western subjecthood. What we witness in these works, however, is not only the decomposition of the conventional subject but also its reconstitution as a (temporary) locus of meaning, creative inspiration, and action. I have suggested that there is in the postmodern works we are examining very little nostalgia for past conventions, but equally, that there are successful attempts to remember a new sort of subject, not one that sees himself or herself as transcendent, perdurable, or particularly powerful, but one who nonetheless tries to enact critique through art. There is a danger in postmodern and poststructural thinking of producing what Paul Smith construes as a 'purely *theoretical* "subject"', removed from the political and ethical realities' of what he aptly calls 'agency' (xxix). Yet there is also a growing awareness that a provisional agent is necessary if any critique of society is to be effectual. Feminist analyses of culture and identity have been at the forefront of this change. As Hutcheon puts it, 'feminist theory and art . . . know they must first inscribe female subjectivity before they can contest it' (226). In the final chapter, I want to test my allegation that this positing of social and political agency—through what has, with respect to Foucault's work, been called 'counter-memory'—is a major facet of postmodern practice in the Canadian visual arts.

NOTES

[1]On the representation of self in Tod's earlier work, see Karen Bernard, 'Ironing Out the Differences: Female Iconography in the Paintings of Joanne Tod', in Linda Hutcheon, ed., *Essays in Canadian Irony* 2 (March 1989), 1-9, and Bruce Grenville, *The Allegorical Impulse in Recent Canadian Painting* (Kingston: Agnes Etherington Art Centre, 1985), 30.

[2]Lacan briefly discusses the phenomenon of the evil eye. See *The Four Fundamental Concepts of Psycho-Analysis*, 115.

[3]'Bold Reminders of the Painter's Power', *Globe and Mail*, 30 Jan. 1990: A13.

[4]Diane Farris Gallery, Vancouver, 24 March–11 April 1990.

[5]*Fragments* (Toronto: Mercer Union, 1989), n.p.

[6]As Peggy Gale has noted in 'At the Silent Centre', *Canadian Art* Fall 1989: 92.

[7]On this image, see Chantal Pontbriand, 'A Canadian Portfolio: Tunnel of Light', *Canadian Art*, Winter 1988: 66-9.

[8]On Gasse, see Cyril Reade, 'Restructuring Landscape', *C* 22, June 1989: 63.

[9]Quotations are from the narration to *Lamented Moments/Desired Objects*.

III. REMEMBERING SOCIETY

'Any philosopher who deploys the concept of an image in his account
of memory is bound to try to explain how we can tell (if we can) that an
image we have now is related to the past. . . . How do we know that
an image does not relate to the future, rather than the past?'

Mary Warnock, *Memory*, 16

'Memory . . . does not resuscitate a past which had been present;
it engages the future.'

Jacques Derrida, *Memoires for Paul de Man*, 50

The final works to be considered here are immersed in memories that will
be familiar from our discussions in the first two chapters—recollections of
art's history and of the subject—but each moves in its own way towards
an explicitly social and frequently more specifically political context for
that which it images. My claim is that these commitments help us to see
the profound future orientation of postmodern memory, its desire to
intervene constructively to effect social and political change. Mary
Warnock argues that any such expectations are more the province of
imagination than of memory (16), and of course memory and the imagi-
nation are especially closely linked when we speak of artistic productions.
The paradoxes of temporality notwithstanding, however, the works in
this chapter demonstrate that the future is frequently and effectively pro-
jected in mnemic terms. If we are to evaluate postmodern artistic practice

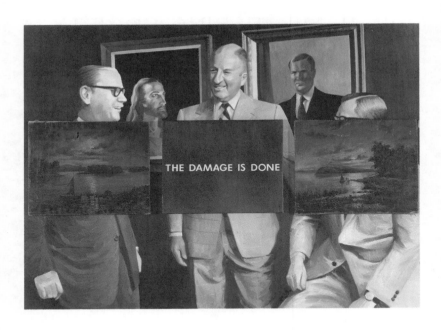

18 Janice Gurney,
The Damage is Done (1986)

in this country, we must take into account its positive (not to say neo-conservatively 'affirmative') self-image.

Janice Gurney's *The Damage is Done* (1986; Plate 18) provides an excellent example through which to consider the mutual infiltration of art-historical recall, the construction of a subject as source for a work, and the social and political ramifications of these memories. This complex painting—or should we call it an assemblage?—has lost none of its ability to shock its viewers into reflections on the notion of artistic ownership (by the artist and commercially), of a work's 'integrity', and of claims to originality in light of which the term 'appropriation' can assume damning connotations. These and related issues are as topical in 1990 as they were in 1986, despite Gurney's attempts (with this and many other works in which she employs another artist's image as a 'support', like *Portrait of Me as My Grandmother's Faults* (1982), using an Andy Patton canvas, or *1001 Details from 'Genre'* (1988), which works on a painting by Will Gorlitz called 'Genre') to have us re-examine the premises according to which we might feel distress at her actions. Her art-historical reflection is literalized by the underlying layer of this work, which is (or should we say 'was'?) a painting by Joanne Tod called *The Upper Room*. Gurney asked Tod for a support of the right size, without specifying what might be on it, and then proceeded to enact on this surface what memory itself always effects (though usually less materially): change. We should remember that Tod's image itself cites a once-potent moment of art's history and radically re-contextualizes it, since she has reproduced the famous Saltzman image of Christ in the background of her boardroom scene. Although Gurney and Tod are friends and Tod was consulted initially, *The Damage is Done* is no more a collaborative work than was Tod's 'original'. On top of what is already a double art-historical appropriation, Gurney has attached three panels. Those on the left and right are 'actual' nineteenth-century landscapes that she found and bought in a Vancouver antique store. The centre panel was executed by Gurney and frames the not unambiguous title: 'The Damage is Done'.

Gurney's physical layering reminds us of the veils we look through—and that look back—in *Screen*, even though she understands these two pieces to represent somewhat different paths in her career, the physical and potentially political with *The Damage is Done*, and the photographic with *Screen*, which focuses more on the nature of the subject. Yet both works investigate the status of originality, the putative uniqueness of artistic images—the von Stroheim clip and the Tod painting—and the sense in which an artist is an origin for a work. Memory is in both cases the rubric for this research. Just as it appears that there is no essential, original subject

in *Screen*, so too *The Damage is Done* makes it impossible for us to find either an essential work within its layers or an essential artist. Each potential source is doubled and re-doubled: there are at least four 'signature' works of art here. If we work back spatially, we have the anonymous landscapes (which because of their damaged state appear without signatures but which have been valued as art in the antique shop, by the person who sold them, the person who painted them, and by Gurney herself), the Tod painting, the Saltzman Christ, and the anonymous portrait to the right, which is Tod's but not Tod's. Then there is the conglomerate called *The Damage is Done*, which—significantly—Gurney *doesn't* sign. This spatial, temporal, and ultimately philosophical regress could be continued, since the nineteenth-century landscapes are very much in the style of earlier British and European views, which themselves of course are indebted to seventeenth-century Dutch models in particular.

Though I want to argue that damage is done mostly to the privileging notions of originality and intentionality, Gurney's wilful *use* of Tod's canvas and the landscapes demands that we read the title again. Tod's work is quite graphically defaced—especially when we look at its right-hand side, where the man's head is blocked by the landscape panel. Physical damage is done as the three panels are attached, and most importantly to most viewers, the 'integrity' of the underlying work is impinged upon. The latter issue, with all its emotional and legal overtones, has been discussed by Lawrence Alexander in an article tellingly entitled 'Moral Rights and the Visual Artist'. Alexander examines, in light of several contemporary examples, the pending legislation designed to protect artists and their work. 'With a painting, sculpture, or engraving,' he writes, 'integrity is treated as the integrity of the work itself; *any* modification of such a work violates the right of integrity' (16). Alexander condones this definition, and there is little doubt that many apparent defamations of works would be subject to redress under these terms. Since Alexander's article reproduces *The Damage is Done* prominently at its outset, we seem to be asked to consider this 'case'. But curiously, the author doesn't mention the work at all, perhaps because it would prove too difficult a test for his would-be law of integrity.

Alexander claims that 'in most cases, it is impossible to separate the personality of the creator from the object she has created, so [defamations of various sorts] . . . constitute a direct and personal assault on the integrity and reputation of the individual involved' (14). This statement has the 'correct' political ring, but it assumes much of what *The Damage is Done* contests with its overlapping memories. Who is 'the individual involved' when we reflect on the unstable postmodern subject? What is 'the object'?

These are not the merely 'theoretical' quibbles that Paul Smith warns against, since if Alexander's law were enacted, Gurney would be guilty of violating integrity—though it becomes quite impossible to say whose, since we would then become trapped in the infinite regress of originality relayed above. In these complexities, we can perceive the social and political implications of *The Damage is Done*.

'Damage', as Gurney here presents it, is not entirely negative nor avoidable. As a re-using, a recontextualizing, her version of damage is nothing other than the process of memory itself, a process without which art cannot exist. Works 'damaged' in this way maintain their sentimental and economic value, as the scarred yet preserved landscapes suggest, and as we saw with *The Unveiling of the Cornucopia* (Plate 2). And *The Damage is Done* dramatizes the productive potential of such reconstitutions of images. By partially concealing the boardroom scene with scarred landscapes, Gurney takes our memories in another direction, towards environmental concerns (also an issue for Tod). The self-satisfied men in the picture seem to have made a decision, one that is sanctioned not only by a predecessor or colleague whose image hangs behind them but also by Christ, through the inclusion of his image. Could this decision in some way impinge upon the sort of pastoral scenes of nature to which damage has already been done? 'The Damage is Done' is a clear and by implication irrevocable statement about the past. By memorializing and destabilizing the past's referents, however, Gurney is able to speak to our collective futures.

Robert Wiens's 1986 work *The Rip* (Plate 19) again makes present this extrapolation of personal memories into social and political statements directed towards future change. On a low, grey table, we see a methodically produced miniature movie theatre. It is constructed like a movie set, and in this quite material sense *The Rip* is a creative recollection of Wiens's own experience in building full-scale sets from 1981 to 1985. This is the work's most recent temporal and experiential frame. Yet we can see by approaching the open end of the piece that it has an inside, too, an interior that holds more memories for Wiens and that also invites the viewer's individual reflections. Looking down what we might aptly call the 'nave' of Wiens's theatre, we see an illuminated but blank screen. There are no seats to obstruct our view and no images appear, but the space is far from empty, since for the artist this enclosure is redolent of childhood trips to the Vogue Theatre in Leamington, Ontario.

All of these quite personal and immediate memories are supplemented, overlapped, and indeed framed by Wiens's recollections of a movie theatre in Whitehorse, experiences that are distilled in the text that accompanies

19 Robert Wiens,
The Rip (1986)

The Rip and gives it its title. On a nearby panel, he inscribes the following text:

> The rip was small when it first
> appeared. It began when an Indian
> poked a knife through the screen.
> Later a bottle was thrown through it.
> The rip continued to grow. Eventually
> it became impossible to ignore.

This story belongs in a sense to Wiens, but the recollection he narrates here is more communal—an 'exchange' (recalling Geleynse's *Fear of Memory*) more like a piece of local lore—than either of his other contexts for this work, his job building movie sets and his childhood excursions to the movies. This text moves us from an interior world of private memories to the social context. Apparently, the initial ripping of the Whitehorse screen was a response to a 'cowboys and Indians' movie starring Anthony Quinn as the leading Indian in a situation where the Indians 'won'. The knife wound was a gesture of anger and frustration at the stereotyped representation of Indians and the appropriation by Hollywood and Quinn himself of natives' right to represent and act for themselves. The rip and ensuing damage to the screen, then, *were* compensatory political gestures. Read this way, the following line in Wiens's text takes on metaphorical significance. 'The rip [that] continued to grow [and] . . . became impossible to ignore' was, of course, literally in the viewers' field of vision, but it was also a social *rift*, an irreparable and continuing schism between cultures and peoples in Canada's north.

Both before and since *The Rip*, Wiens has combined these memories not so much to heal or repair a social problem as to make it present, to keep the memories and their implications alive. In *Before the Rising Spectre* (1984), for example, he brought alive the need for social involvement in issues of nuclear disarmament by combining banner-like photos of demonstrations (reminiscent of the activism of the 1960s) with an immense ear and eye, admonitions to listen, watch, and act. More recently, in *Bush T.V.* (1989), he engaged with the politics of logging in northern Ontario, which if allowed in the particular area on which he focuses photographically, would have a detrimental environmental and social impact. In these works as in *The Rip*, Wiens includes himself and each viewer in the social problems he visualizes; here he projects the issue of the rift between native and other Canadians into the future, but not by having us simply see the rip his text describes or by reproducing a still from the Quinn movie. Because the screen we see is blank, the viewer can project individual

20 Carl Beam,
The North American Iceberg (1986)

memories. But these memories are in a sense also already projected, screened by the light that beams back at us from inside *The Rip* and framed both by the boundaries of Wiens's theatre and by the text. Our memories are not determined, but they are directed by the co-ordinates Wiens establishes. In these ways, the complex imbrication of memories screened in this image is typical of a postmodern construction of the past that we have seen at work in Gurney's *Screen* especially. Wiens's work also addresses the mnemonic forging of a subject in its interactive combination of childhood and adult memories, and, again like Gurney's, his written narrative reads the viewer in the sense that it at least partially guides our response to the work. More like *The Damage is Done*, however, *The Rip* moves us to consider present and impending social and political conditions in light of a projected past whose 'projector' or agent we can only provisionally identify.

Wiens isn't alone in his concern with the plight of native Canadians in our culture: Two native artists in particular—Carl Beam and Ed Poitras, who is Métis—use memories of their own people's experience to rewrite history in a way that might change the future. Beam's *The North American Iceberg* (1986; Plate 20) is a pentimento-like collage displaying the 'tip' of many layers of native history, a forgotten (by white culture) narrative that he physically recollects and into which he inserts his self-portrait. In a 1989 exhibit entitled 'Indian Territory' at the Power Plant in Toronto, Poitras presented a variety of memory works that manifested the clash of European and native cultures. In *Erase*, for example, a text outlining the evocative shape of a buffalo surrounds an old photo of a prairie home. The words describe the American General Sherman's plan to decimate the buffalo stocks in order to cripple the native population. Analogously postmodern archaeologies are constructed by the Toronto collective Fastwürms. In *Father Brébeuf's Fugue State* (1983), for instance—an elaborate conglomeration of supposedly old relics from Brébeuf's seventeenth-century mission to the Indians and recent artefacts—they reflect on the official version of Canada's colonial history.

The frequency with which we witness a melding of mnemonic fabrications of the social, the subject, and art's history in recent Canadian art should be clear by this point, not least because this book itself sets up terms and viewpoints for recollecting the themes and works that it discusses. Important pieces that explicitly recall architectural history—Jane Buyers's installation of sculpture and drawings entitled *Language/Possession* (1987–88; Plate 21), and William MacDonnell's painting *22 July 1968/16 Nov. 1885* (1986; Plate 22), Melvin Charney's *Les Maisons de la rue Sherbrooke* for the *Corridart* exhibitions during the 1976 Montréal Olym-

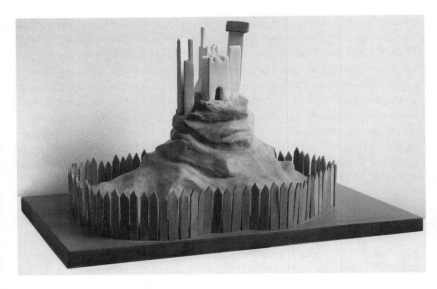

21 Jane Buyers,
Language/Possession (1987–88)

pics (Plate 23), and Krzysztof Wodiczko's projection on the London, Ontario, County Courthouse (1983)—also move beyond this act of citation to make their own political statements.

Language/Possession is reminiscent of two works from Chapter I. Like Favro's *Van Gogh's Room*, this piece sculpturally translates a painted image, this time the hill town at the left in the Italian painter Simone Martini's fresco *Guidoriccio da Fogliano* (1328) in the Palazzo Publico, Siena.[1] Behind this central sculptural reminder Buyers has placed a text (slightly altered in her memory) from French thinker Roland Barthes's *A Lover's Discourse: Fragments*:

> Language reveals the equivalence of love and war: in both cases it is a matter of capturing, conquering, possessing. (188)

In its thematization of the war-like struggle of love, this text—when placed, as it is, in the context of art-making—is reminiscent of the right-hand, vertical passage in Clay's 'Eye to Eye', the text that emphasizes how the artist must control his or her medium. Like Clay's, Buyers's memory works through art-historical and textual citation to make a social comment on the subjugated position of women. Buyers's assertions, however, are more overt. The two drawings that are part of *Language/Possession* are themselves reflections, works 'after' Martini and Barthes, and indeed also chronologically later than the sculpture that centres the piece. This example of Barthes's musing on love is taken from a context in which he expressly ponders the way the past inscribes itself in contemporary love language: 'Each time a subject "falls" in love, he revises a fragment of the archaic time when men were supposed to carry off women' (188). By placing Barthes and Martini together—a thinker from Buyers's present and an early Renaissance painter—*Language/Possession* conflates time in order to make a point about abduction, of art and of women. On one of the accompanying drawings, Buyers makes her own thinking about this use of sources and manipulation very clear: can 'Martini illustrate the ideas of a modern French philosopher . . . [and] say something about the position of woman?' she asks. We may answer 'yes' in light of the ways individual and art-historical memories project into the present and are themselves recalled in terms of contemporary concerns.

Language/Possession does away with the linear time and the evolutionary obsessions typical of much art history and relies instead on memory's more synchronic and creative work. But this does not mean that Buyers has 'used' Martini irresponsibly, or even that she has taken his work out of context. The *Guidoriccio* is a very public memorial to the general who

lends his name to the fresco, the political leader who 'liberated' the town that Buyers has reproduced sculpturally. But this liberation was of course a matter of conquering and possessing. Barthes sees the lover as a military man whose 'discourse stifles the other, who finds no place for his own language beneath this massive utterance' (*Discourse*, 165). In combining these views, Buyers seeks to give a voice back to the dispossessed. Her fortified hill town is no longer Martini's, nor can it be totally ruled by Barthes's text. It is both too small and too solid for either of these masculine voices to enter; in her words, as architecture, it is a mnemonic 'container for visual and emotional experience'.[2] By shifting the syntax of art's language from painting and text to sculpture and architecture, Buyers at once acknowledges and resists the 'equivalence' of love and war. *Language/Possession* may be playful in its manipulation of scale and its light-hearted colouring of the town, but its implications work in the arena of gender politics. In Buyers's hands, scale domesticates, feminizes, and ultimately mocks the masculinist sense of heroic conquest in both love and war. Her exploration of women's place in our culture focused on architecture, scale, and memory before *Language/Possession*—especially in the 1983 exhibit called 'Mixing Memory and Desire' held at the Art Gallery of Hamilton, where *The Life of the Mind* (one of six miniature rooms within the installation) presented memory as a bookcase divided into categories tailored to what Frances Yates calls 'the art of memory'—and since, in her exploration of 'women's work' in 'Industry and Idleness', an exhibit at the Garnet Press Gallery in Toronto in 1988.

William MacDonnell's *22 July 1968 / 16 Nov. 1885* (Plate 22) is a complex web of historical, art-historical, and personal memories conveyed once more through images of architecture. The weight of history is seen in both of this painting's two parts. On the left, a double image of St Boniface church in Winnipeg alludes to two important dates, the first, when the church's interior was burned out, and 16 Nov. 1885, when Louis Riel was hanged for treason (in Regina). On the right is an abstracted and highly conceptual 'portrait' of Riel himself made from the outlines of three tables. The two panels contrast sharply in their use of imagery, yet they are linked by references to Riel—the noose in the bottom left corner of the left panel and the inscription 'Louis, Louis' on the right section. And quite personal recollections of MacDonnell's own interests suffuse the entire painting, since he has represented other famous church façades (St Mark's in Venice and Sta Maria Novella in Florence), as well as geometrically displayed chairs, in earlier work. What this painting performs is a mnemonic alchemy with history, melting it down, as it were (like the lead he uses on the canvas and like the mysterious black mound of matter in

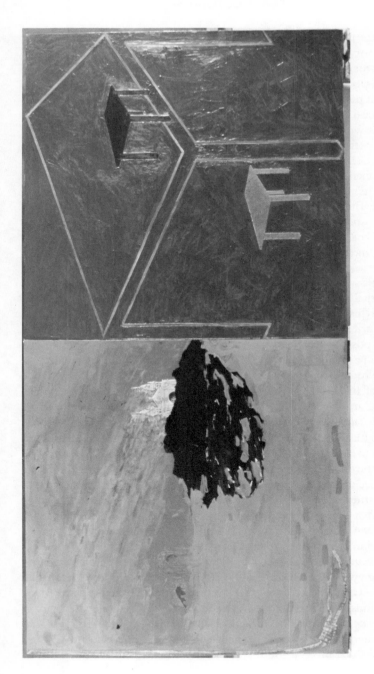

22 William MacDonnell,
22 July 1968/16 Nov. 1885 (1986)

front of the blazing church), in order to redeploy it in the present. History and memory are shown to be different yet interdependent. History is the official story, the collective account, but it is made up of individual memories coming from the subject's side of events. MacDonnell has us recall that there are many St Bonifaces and many Riels.

If we read this bipartite image and its laconic title from left to right, it is clear that we are remembering Riel (the date of his execution in the title and his portrait) *through* another, much more recent, event in the culture of western Canada, the fire in the cathedral. This filter effect is typical of MacDonnell's approach. Time elapses in the left panel, since we see the fire and its result, the still-glowing shell that is all that remained of St Boniface. But the ruin is powerful as a cultural memory, even though its past was 'updated' by the rebuilt, thoroughly modern interior constructed after the conflagration. In MacDonnell's painting—as in the other post-modern memory works discussed here—we can view the past only through the present, yet we do not therefore form a pastiche of this past capriciously. The shell remains. In the same way, MacDonnell pictures Riel partially through the formal and conceptual operations familiar to him from his teaching at the Nova Scotia College of Art and Design. But his memories of these procedures again constitute only a rubric for what is in sum a postmodern history painting—a commemoration—constructed from the particularities of memory, a work that will not let us forget a political leader from our national past.

One of the most instructive and powerful memory works in recent Canadian art was Montréal architect and artist Melvin Charney's project *Les Maisons de la rue Sherbrooke* (1976; Plate 23). The 'Corridart' exhibition, of which this full-scale reconstruction of an historic house was a part, was designed to complement the festivities of the 1976 Olympics, but four days prior to the opening of the games, officials cancelled the entire exhibit and demolished its sixteen projects along the five-mile route. The entire exhibition, Charney said, was 'a mimetic of human memory' (McConathy, 38), a repetition of the city's own development; or, as Diana Nemiroff put in it her 1986 essay on Charney for the XLII Biennale Di Venezia catalogue, it was 'a recuperation of forgotten strata of references' (12).

Les Maisons itself was a façade duplicating the front of a nineteenth-century greystone house on the opposite corner (same side) of Sherbrooke and Saint-Urbain. Its movie-set-like construction worked as a screen for recollections of what the city used to be like along one of its main corridors before empty lots (in one of which Charney built his structure) were cleared for civic 'development'. The mirror effect created by *Les Maisons* only reinforced the absence of a permanent house, of historical

23 Melvin Charney,
Les Maisons de la rue Sherbrooke (1976)

continuity, where Charney built, and the lack of enlightened city planning. By duplicating what had been an integral part of the streetscape in the all too fragile 'medium' of scaffolding and plywood, Charney not only spurs our memories but also demonstrates the vulnerability of the material incarnations of a city's and culture's past. Like another part of Corridart, *Mémoire de la rue* by Jean-Claude Marsan, Lucie Ruelland, and Pierre Richard, which collected and displayed in photos and prints recollections of the street's history, *Les Maisons* worked with the urban environment to sound a warning about cultural amnesia that went far beyond nostalgia.

The social and political dimension of Charney's architectural memories are seen again in his unrealized project for the Dokumenta 7 exhibition in Kassel, West Germany. *Better if they think they are going to a farm* . . . (1982 and following) was to be another façade, this time that of a farm building, erected in front of the Kassel train station. Charney's chilling reference—which we can see in his drawings for this project—was to the Nazis' construction of a similar façade at the entrance to Auschwitz. This work reminds us in the most visceral terms that even seemingly banal architecture stores memories, and that this architecture has been, and can still be, (ab)used politically. Again, Charney is not nostalgic about the innocent, original state of any building. Across a drawing connected with this project, he writes: 'Idealized farm "façade" cuts into common understanding of the façade as it is riveted . . . in the memory of history.'[3] His alterations and redeployments of architecture show the instability of culture and the need to recollect its mistakes. The same can be said of Charney's partner in the 1986 Venice Biennale, Polish-born Krzysztof Wodiczko.

When he immigrated to Canada in 1977, Wodiczko began to develop a type of intervention into the public spaces of architecture and social memory that has justly become famous around the world. His signature 'public projections' beam disruptive images onto the façades of various buildings and monuments at night, altering their appearance, their context, and frequently recalling for their viewers historical and contemporary meanings suppressed by the supposed freedom of a 'public' site in the West. As the artist explains:

> The aim of the memorial projection is not to 'bring life to' or 'enliven' the memorial nor to support the happy, uncritical, bureaucratic 'socialization' of its site, but to reveal and expose to the public the contemporary deadly life of the memorial. The strategy of the memorial projection is to attack the memorial by surprise, using slide warfare, or to take part in and infiltrate the official cultural programs taking place on its site. (10)

Official public memorials, then, in fact attempt to kill memory; for Wodiczko, theirs is an 'obscene necro-ideology' (4) that must be disrupted by acts of anamnesis. Wodiczko implies that structures of institutional power are so completely absorbed by architecture as to become literally invisible. How often do we pass by the many victory columns that commemorate past military triumphs in our civic spaces and think nothing of the horrors of war that these memorials in fact suppress? Wodiczko's projections make such forgetting difficult. Onto the column in downtown Toronto commemorating the British victory in South Africa, for example, he projected an image of a hand stabbing with a knife (1983). In the Schlossplatz, Stuttgart, in the same year he projected the image of a missile with a nuclear warhead on another victory column, implying that wars and their destruction are anything but things of the past to be glorified, especially in West Germany, the likeliest battleground (at that time) for any confrontation between NATO and the Warsaw Pact countries. These memorials, then, are not able to slip into the oblivion that their seeming accessibility paradoxically promotes: like Charney, Wodiczko seeks a much more active public awareness of architecture.

There is one important point of comparison between Wodiczko's projections and those of Murray Favro considered in Chapter I. Both employ the basic technology used in the teaching of art history—the slide projector—and both implicitly offer a critique of the ways in which art's history is ideologically constructed. Wodiczko has executed several projections on architecture that exists not only as a public memorial of some kind but that is also important in the history of art. His works in Venice in 1986, for example, revealed the interconnectedness of art history's validation of certain objects, the tourist trade, terrorism, and the military. Onto the famous campanile of San Marco he applied (from top to bottom) a camera, an ammunition belt, and at the base, the bottom of a tank with its tracks heading towards the famous square. Venice's history as a trading centre and a military power, he has suggested, is re-enacted today in menacing ways:

> mercenary pirates of political terrorism are threatening to cut off the commercial routes to tourism's global empire, of which Venice is the strategic center. To secure this empire's operations, in particular its overseas summer crusades, the imperial jumbo-jet fleet demands military protection. Thus the contemporary fear of terrorism joins with the fear of the entire empire of tourism, finding its center today in Venice, whose embattled history and architectural memory are haunted by it already. (18)

24 Barbara Steinman,
Cenotaph (1985–86)

Wodiczko's projections expose the unspoken allegiances between a building's past and present, what we might call its institutional power. While offering potent reminders of the ideologies of architecture, however, he seems also to acknowledge his inevitable (and typically postmodern) complicity or 'collaboration with its power'.[4] He is very aware of public censorship in the West—he was required, for example, to excise the terms 'power' and 'ideology' from the article just cited (Crimp *et al.*, 40)—but also of the need to take advantage of opportunities to make public statements with his work.

One such critique was effected by the *Courthouse Projection* in London, Ontario, in 1983. The normally unremarkable face of this building was transformed by the projection of one of its court's 'products', the incarceration of prisoners, suggested here by the hands holding onto cell bars. The person found guilty is faceless, just as this brutalist façade itself effaces one of the results of its judicial power. In being forced by this manipulation of the architecture to remember one aspect of a major public institution's power, the building itself changes through its viewers' eyes. We see—perhaps for the first time—the cell-like windows that range between the hands Wodiczko has projected, the impersonal and authoritarian potential of this late modernist architecture and its functionality. It is also worth remembering that these projections are, like memory itself, ephemeral and constantly mediated by factors as divergent yet crucial as the weather and a given civic authority's permission to 'use' a building in this way. The *Courthouse Projection* lasted for little more than an hour (except in still photographs), but its salutary effects live on in recollection.

Montréal installation artist Barbara Steinman's *Cenotaph* (1985–86; Plate 24) offers an analogous but more permanent meditation on the evanescent phenomena of memory. A cenotaph is of course a public memorial to the dead, a way of keeping memories of them alive. But like Wodiczko's memorial projections, *Cenotaph* works to show how this sort of monument again effects the demise of certain specific memories. As we enter the darkened room in which this piece is now installed in the National Gallery in Ottawa, we are confronted by a large, dark, pyramidal form with what appear to be flames flickering at its top. Around the base are three granite slabs, each of which carries part of a quotation from the political theorist Hannah Arendt:

> The radicalism of measures to treat people as if /
> They had never existed and to make them disappear /
> Is frequently not apparent at first glance

Projected onto the sides of the room enclosing *Cenotaph* are images of unknown 'disappeared' people. The work is a highly technological recreation of more traditional cenotaphs: the 'fire' is actually the product of a video loop and the faces we see are reminiscent of media photos. The granite 'tombstones' are not inscribed with names but instead convey textual information. Like her more recent installation *Borrowed Scenery* (1987), then, this work questions both how and what we remember as individuals and as a society. And like so many politicized reflections on memory, *Cenotaph* probes the conventionalization of recollection, the extent to which we are bound by forms like the cenotaph and also the possibility of employing them differently.

Steinman does not keep a flame burning for 'official heroes',[5] but explicitly for those unknown casualties of totalitarianism. Hers is an alternate memory not only of nameless people but also of the possibilities, both positive and negative, of the contemporary information systems—video, newspaper photography and text, art—that *make* the past in the present. These vehicles can be used to designate individuals and to perpetuate their dignity, as here, but they are by no means necessarily benevolent. Since we tend to elaborate narratives from the smallest bits of information, information selected by those who present it, many different interpretations of events are plausible and much is inevitably forgotten. Even in this case, a viewer cannot read all of the Arendt passage at once, since it is presented in fragments split among the three sides of the pyramid. Any number of stories could be imagined to make sense of the incomplete statement 'the radicalism of measures to treat people as if' as it combines mentally with the wall images. I would suggest, however, that this very fragmentation productively duplicates the processes as well as the specific contents of memory: we as viewers are urged to find meaning by piecing together text, images, and our own recollections. The structural systems of memory in our culture are revealed, not masked. The work does not lecture: it instructs by giving us the opportunity to experience—and question—the norms of public commemoration.

This sense of inviting viewers to participate—to recognize their inevitable complicity in the discourses of their society, perhaps, but thereby also to offer alternatives—is a typically postmodern mode of political commentary, and an installation is very often its vehicle. This is true nationally and internationally. For example, London, Ontario, artist Jamelie Hassan is best known for works that encourage the beholder to engage politically with her subject through emotion and memory. In *Los Desparecidos* (1981), she recalls her experiences in Argentina, specifically an incident when a grandmother of a disappeared person gave her a kerchief, a memento of

the missing person and the grandmother's vigil. Hassan extended this mnemic connection by making and exhibiting ceramic kerchiefs representing others whose disappearances she subsequently researched. *Primer for War* (1984) is a more complex interweaving of personal recollections—in the form of photos taken on a trip to Germany—and pointed textual statements on warfare borrowed form an American First World War manual. These parts are brought into proximity on top of a long, low bench, where we see ten small bible-like books, text on one facing leaf, image on the other. A viewer needs to bend over to read the text and see each photo clearly. This involvement is voluntary, but it can lead one to question the odd combinations seen, their rationale, and the authority of their presentation. Outside Canada, the work of Hans Haacke best exemplifies what I take to be a postmodern concern for the social and political. Like Steinman and Hassan—and very like Bruce Barber, to whom I will turn shortly—Haacke seeks to get inside systems of institutional power in order to expose their codes to critique. His controversial *U.S. Isolation Box, Grenada, 1983* (1983-84), for instance, replicates one of the inhuman portable detention boxes used by the US army in Grenada, boxes whose existence was initially denied and that were largely unknown because of press censorship. Haacke's installation literally remembers this instrument.

Many of the works discussed here could be said to engage with the politics of memory in more oblique but no less important ways. If we again define politics very broadly as the dynamics of an ever-shifting but perpetually unequal relationship of power within the polis, then mnemonic interruptions and revelations of this power on the inter-personal as well as inter-national plane can be construed as political. Clay's *Lure* is such an intercession in the tradition of modernist abstract painting, as are Gurney's *Screen* and *The Damage is Done* in the politics of the formation of a subject and the ethics of ownership respectively. But as we have seen, and as the final two works I will examine demonstrate, postmodern visual memory is also effective in the realm of state politics.

With *Nam II* (1990; Plate 25), Bruce Barber continues and revises his project of re-collecting and reconstituting images and texts about the Vietnam war in ways that alert us to both the dangers and the critical potential of memory's constant construction and elision of the past. In forging an interaction between texts and images that are themselves memories of Vietnam, Barber works in the sphere of culture's representation of its own history, just as he did in his 1985 *Remembering Vietnam Triptych*, whose left panel superimposes one of United Technologies' (a major arms manufacturer) eulogizing texts for the soldiers who fought in Vietnam

25 Bruce Barber,
Nam II (1990)

over a picture of a military massacre. This text begins, 'Vietnam occupies that part of the mind inhabited solely by memories,' and continues, 'Let us begin by remembering.' This is exactly what Barber does both here and in *Nam II*, but his interjected recall seeks to compensate for any particular memory's inevitable double, forgetting. Like Hans Haacke in his analogous representations of social propaganda broadcast by companies like Mobil, he doesn't suppose that one true account can be recovered—he is too involved himself in the (re)construction of history to take such a simple stand—but his work does strongly suggest that some memories have a *moral* superiority, and that these interventions are often systematically repressed in culture's current projections about the Vietnam War.

Barber's *Nam II* thematizes popular culture, specifically its use in the comic-book (called *The 'Nam*) of the famous photo by the American Eddie Adams of execution that we see reproduced here. The image shows (then Colonel) Nguen Van Loan killing a suspected Vietcong terrorist in the streets of Saigon in 1968. We think we know and understand the horror of this picture, but this supposed familiarity is for Barber itself symptomatic of the danger of amnesia. The 'original' circumstances in which the photo was taken are far from clear. There are allegations that the shot was posed. But it operates quite uncritically in the comic-book example of popular imagination as an image of 'our side's' rightful use of power. For many, the Pulitzer Prize-winning photo was and remains just the opposite, but the comic book alteration remembers things differently. In *Nam II*, Barber re-poses this question of meaning yet again by recontextualizing what is already a reconstituted journalistic photo. He includes a montage of quotations from Adams as a way of rethinking the role of 'documentary' photography in our writing of the history of the Vietnam War. Barber states: 'I am interested in the notion advanced by Susan Sontag that one or two significant images could be said to summarize a whole war. This execution shot is one of them, and Adams's statements seem to me to allow some questioning of the veracity of his photo's "decisive moment".'[6] As with *The Damage is Done* by Gurney, there is no original to return to, but there is an ethics of memory to be asserted through—not in spite of—the ongoing politics and mnemonics of representation.

Barber does not claim to be the first or only artist to expose for us how society creates its present versions of the past by appropriating 'documentary' artifacts. At least as we look back on them now, the photomontages by German artist John Heartfield (1891-1968) in particular stand behind this practice. This example returns us to the modern–postmodern debate: if Heartfield as a modernist took contemporary images of fascist Ger-

many and, by recontextualizing them, evolved a powerful critique of his society—which he did—why would I claim that Barber's work is distinct enough to be called postmodern? Part of an answer lies in chronology: Heartfield's works did not have precursors in the sense that Barber's do; postmodernism's belatedness partially accounts for its self-consciousness. More significantly, although both Heartfield and Barber use their political memories and overtly political images to make statements, their critiques are as different in some ways as the societies in which they grow. Germany in the 1930s and Canada in the 1990s may not be as absolutely separate as we would wish, but it is nonetheless the case that Heartfield's montages were less concerned with disclosing how representation can manipulate 'reality' than with immediate social intervention. Inevitably— because of historical differences and elapsed time—Barber's *Nam II* is more reflective and theoretical. Its postmodern politics enjoy the relative stability of Canada in 1990 in recalling the past (Vietnam, and indirectly, Heartfield) and in entertaining a future in which we might see and read more politically. *Nam II* employs the privilege of critique at a time when a laxness and complacency of memory threaten our society with the repetition of previous political misadventures.

Like Barber, Stan Denniston questions the often assumed veracity of photography while simultaneously exploiting its mnemonic potencies. Denniston's *Kent State U. / Pilgrimage and Mnemonic* (1982/1990), however, finds its political voice more through personal experiences of how memory moulds the subject and then projects into society at large. The history of this work illustrates the point. It is a triple mnemonic: the piece is itself a revision of Denniston's 1982 montage of the same name, which in turn memorialized his reactions to the murders at Kent State University in Ohio in 1970, when the National Guard shot and killed demonstrating students. Denniston's procedure in creating and recreating *Kent State U.* also underlines its powerful and unusual examination of place memory— our corporeal relation to space—a scrutiny that significantly addresses what one prominent commentator sees as 'one of the most conspicuously neglected areas of philosophical or psychological inquiry into remembering' (Casey, 183).

Denniston physically separates his 'pilgrimage' to Kent State from his 'mnemonic' of his experience. When he travelled to the site, he explicitly sought to memorialize it, and the result is a somatically particularized montage of photographs that pans up from his own feet. The recollection, however, is constructed of images taken in Toronto and Victoria that *reminded* Denniston of Kent State. They are 'triggers' of his memory of another place. In recreating Kent State with Canadian imagery, he is both

personalizing the meanings of his trip and *placing* Kent State in Canada, showing that in spite of the calm that seems to pervade both sets of images, the sort of rampant and indiscriminant violence that occurred in Ohio's past could be in our Canadian future. Memory is of the future as much as of the past; indeed this dedication to what is potentially yet to come must be a prime motivation for the construction of any memorial. There is something desperately isolating about such an attempt to mourn death. As Derrida has it in his own eulogy to the late Paul de Man:

> We weep *precisely* over what happens to us when everything is entrusted to the sole memory that is 'in me', or 'in us'. But we must also recall, in another turn of memory, that the 'within me' and the 'within us' *do not* arise or appear *before* this terrible experience, or at least not before its possibility, actually felt and inscribed in us, signed. (*Memoires* 33)

For Derrida and I think also for Denniston, 'we come to ourselves through this memory of *possible* mourning' (34). But in *Kent State U.*, this inward-turning, even narcissistic memory work also impinges on the viewer politically.

It is useful to think for a moment about Denniston as a viewer of his own 1982 work, a work that he claims felt 'unresolved', and that he even seemed to repress in his own consciousness by not referring to it publically or even in private for several years. Denniston's recent alterations to the work suggest—in their illustration of memory's constant revision of the past—why he was unhappy with his earlier efforts and why he returned to them. Screened onto the Canadian recollections of Kent State in the 1990 version are images of police violence and social intolerance that are very specifically Canadian: images of the notorious 1981 bath-house raids in Toronto in which Metro police violently lashed out at the gay community. Denniston discovered that this event was indeed the trigger for his own thoughts about Kent State, yet only recently has he made this overlay of associations visible. The addition of these images—clearly brutal even if we don't recognize them from their wide circulation in the press—makes *Kent State U.* at once more explicit and (even) more intricate as an exploration of memory. What we cannot see but might glean from the fact that Denniston was drawn back to his 1982 version is his assertion of the possibility of memorialization, the positive potential of his own social and political agency in keeping memories alive through his work. This guarded optimism, Denniston has said in conversation, parallels the pleasure he felt in participating in the protest marches after the bathhouse raids, intervening quite physically in a political situation. And

of course this demonstration is itself a reminder of the abhorrent results of the students' civil actions at Kent State.

The installation of *Kent State U.* reinforces this sense of communal commemoration. The two panels are designed to face each other (either frontally or at a 90-degree angle); as viewers, we must situate ourselves within their mnemonic construction of history, since we cannot 'stand back' and see both sets of pictures completely at the same time. The spatial and temporal shuttle among projected pasts, presents, and futures that the two panels delineate pulls us into these contexts instead of allowing us a 'pure' vantage point from which we can see both sides at once and then compare and judge. Memories are thus spatialized and framed for each viewer, but as was the case with *The Rip* by Wiens, with its screen ready for new projections, *Kent State U.* allows for the vagaries of each viewer's recollections. Without this anti-didactic flexibility, its political efficacy would be lost to an over-specified, artist-centred context. Put another way, Denniston's triggers—with all the violence implied by the term—must be more than personal. They must allow for other memories and other forgetting.

Like *Nam II*, *Kent State U.* challenges society's amnesia yet is also built on the selectivity—forgetting—of representation. Describing his early *Reminders* works (1978-82; 1987), which are closely related to this piece, Denniston claims that they were primarily an 'exercise in forgetting, not remembering' (1989). In the *Reminders* series, Denniston opposed sets of two images, one taken out of interest at a particular place, the other (shot later and without recourse to the first) an image that in memory reminded Denniston of the first. He went searching for these memories throughout North America—they determined his future for quite a while—yet in order to find them and exercise his memory, he had to forget a great deal about the first image. One of the most complex and interesting pieces from this series is *Reminder #20* (1979; Plate 26). In this example, we see that 'Edmonston, Texas, from the West' triggered a memory of 'Downtown Toronto from King St West'. While these images invite comparison, both formally and thematically, in a sense—and I think this is especially true when one first sees this pair—the pictures are very different. Yet as in memory's workings themselves, it seems that differences are increasingly elided and the profound similarity of feeling between these photographs comes to the fore. Despite the 'business' of the Toronto image, what we begin to see is the dramatic focus directed by the streetcar tracks, a visual pull that is echoed by the tire tracks in the Texas image. Ironically, then, the two places end up looking very alike. What this process allowed him to find were the types of memory traces—visual, spatial, atmospheric—that

26 Stan Denniston,
Reminder #20 (1982/1990)

worked for him as cues. This of course is the procedure he put to use again in *Kent State U.* in 1982 and again in 1990. In 1982, it seems, he had forgotten the bathhouse incidents through which we now see this work. His amnesia allowed certain memories to find their place, however, and what the viewer forgets will also permit other recollections.

Forgetting may be instrumental to the operations of recall, but in its more political dimensions, it is to be avoided. Milan Kundera writes that 'the struggle of [civilization] against power is the struggle of memory against forgetting' (3). This social and political context for the agency of art has become more and more important to Denniston. Speaking of his *Reminders*, he has recently remarked that with these works, he was 'hoping to learn something about the structure of memory, especially *my* memory' ('Talk'). Later work borrows the techniques of the *Reminders* but seeks to make them tell in society at large. Speaking of *Dealey Plaza / Recognition and Mnemonic* of 1983, his memory work about the John F. Kennedy assassination, he claims that 'my memories of these events [labour] *against* the public record or officially sanctioned' line ('Talk'). The same could be said of *Kent State U.*, but here the 'line' might well be the complacent and blind attitude common to so many Canadians that 'this sort of thing' could not happen in Canada. Denniston's spatialized memories prove them wrong, and in doing so, his counter-memories and those of his viewers prove that they can be active agents in a politics of resistance.

Reflecting on the numerous memory works collected here, I believe that it is now possible to refute Marxian literary critic Terry Eagleton's description of postmodernist culture as comprised of 'depthless, styleless, dehistoricized, decathected surfaces' (61), Fredric Jameson's apocalyptic vision of 'the waning of our historicity, of our lived possibility of experiencing history in some active way' ('Cultural Logic', 68), and artist Ian Wallace's definition of postmodernism as 'a term which has come to justify a condition of amnesia by which [the avant-garde's] history of confrontation could adapt itself to the demands of society: that its conflict be symbolic, pluralist, and confined to the limits of fashion' (1984). I have sought to show very specifically that what is and should be called postmodern practice in Canada is, because of its frequent thematization and exploration of memory, anything but an example of amnesia, and thus that it is decidedly historical in new and specific ways. In using these counter-examples against the frequently generalized anti-postmodernist rhetoric exemplified by these statements, I am not claiming that *no* recent art, in Canada and elsewhere, conforms to the ahistorical and depoliticized paradigms of what E. Ann Kaplan has aptly deemed 'co-opted postmodernism' (3). What I hope to have counteracted through this

examination of the specificities of memory, however, is the reductive and absolutist move that would define postmodernism so narrowly and then condemn it so sweepingly. What seems in these three writers and so many others to be a fear of a postmodern gaze—of the questions this gaze might pose—is most commonly a fear that the political interventions of the historical avant-garde are both forgotten and rendered impotent by recent practice. I think that my final chapter in particular demonstrates that the possibility of this sort of intervention has—in a much-changed historical context—been thrown into question but also remembered and redeployed. As Foucault has argued, the 'return'—indeed, I would say all memory—'is not an historical supplement which would be added to . . . discursivity, or merely an ornament; on the contrary, it constitutes an effective and necessary task of transforming the discursive practice itself' ('Author', 116). If the fear of it can be alleviated by understanding in this way how history is made, then perhaps postmodernist memory—its constant collective and individual reappraisals of the subject as potential agent and its recall of its art-historical pasts—can be seen and appreciated for the challenges it presents to received ways of looking and thinking, as well as for the radical perspectives it provides on the active, mnemic construction of reality through art. Through such memory works, we could find paths to the future as well as to the past.

NOTES

[1] This attribution is now disputed, but for Buyers and most people familiar with the work, it is a Simone Martini.

[2] Undated artist's statement.

[3] Cited in Bruce Ferguson, *Künstler aus Kanada: Räume und Installationen*. Stuttgart: Württembergischer Kunstverein, 1983: 39.

[4] Wodiczko, 'Public Projection', *Canadian Journal of Political and Social Theory/ Revue canadienne de théorie politique et sociale* 7, 1-2, Hiver/Printemps 1983: 184-7.

[5] Renée Baert, 'Focus on Barbara Steinman', *Canadian Art*, Winter 1988: 95.

[6] Letter to the author, 5 May 1990.

WORKS CITED AND CONSULTED

Alexander, Lawrence. 'Moral Rights and the Visual Artist'. *Vanguard* 17, 3 (Summer 1988): 14–17.

Barthes, Roland. *A Lover's Discourse: Fragments*. Trans. Richard Howard. New York: Hill and Wang, 1978.

_____. *Camera Lucida: Reflections on Photography*. Trans. Richard Howard. New York: Noonday Press, 1981.

Bélanger, Sylvie. 'Proposal' for *Essai de Synthèse*, 1988.

Benjamin, Walter. *Illuminations*. Trans. Harry Zohn. New York: Schocken Books, 1978.

Borges, Jorge Luis. *Labyrinths: Selected Stories and Other Writings*. Ed. Donald A. Yates and James E. Irby. New York: Modern Library, 1983.

Bryson, Norman. 'The Gaze in the Expanded Field'. In Hal Foster, ed., *Vision and Visuality* (Discussions in Contemporary Culture 2), pp. 87–108. Seattle: Bay Press, 1988.

Bürger, Peter. *Theory of the Avant-Garde*. Trans. Michael Shaw. Minneapolis: University of Minnesota Press, 1984.

Burnett, David. *Guido Molinari: Works on Paper*. Kingston: Agnes Etherington Art Centre, 1981; exhibition catalogue.

Burnett, David, and Marilyn Schiff. *Contemporary Canadian Art*. Edmonton: Hurtig, 1983.

Casey, Edward S. *Remembering: A Phenomenological Study*. Bloomington and Indianapolis: Indiana University Press, 1987.

Cheetham, Mark A. 'Mystical Memories: Gauguin's Neoplatonism and "Abstraction" in Late-Nineteenth-Century France'. *Art Journal* 46 (Spring 1987): 15–21.

_____. *The Rhetoric of Purity: Essentialist Theory and the Advent of Abstract Painting*. Cambridge: Cambridge University Press, 1991.

Chipp, Herschel B. *Theories of Modern Art: A Source Book by Artists and Critics*. Berkeley: University of California Press, 1968.

Clark, T.J. 'Clement Greenberg's Theory of Art'. *Critical Inquiry* 9, 1 (Sept. 1982): 139–56.

Clay, Allyson. *Lure*. Vancouver: Artspeak Gallery, 1988.

_____. 'Artist's Talk'. London: University of Western Ontario, 17 March 1989.

Crimp, Douglas, Rosalyn Deutsche, Ewa Lajer-Burcharth. 'A Conversation with Krzysztof Wodiczko'. *October* 38 (Fall 1986): 23–51.

Davis, Natalie Zemon, and Randolph Starn, eds. *Memory and Counter-Memory*. *Representations* (Special Issue) 26 (Spring 1989).

de Bolla, Peter. *The Discourse of the Sublime: History, Aesthetics and the Subject*. Oxford: Blackwell, 1989.

Deitcher, David. 'Drawing from Memory'. *The Art of Memory/The Loss of History*, pp. 15–21. New York: New Museum of Contemporary Art, 1986.

Denniston, Stan. 'Artist's Talk'. London: University of Western Ontario, 1 Feb. 1989.

Derrida, Jacques. *Memoires for Paul de Man*. Trans. Cecile Lindsay, Jonathan Culler, Eduardo Cadava. New York: Columbia University Press, 1986.

_____. *Writing and Difference*. Trans. Alan Bass. Chicago: University of Chicago Press, 1978.

Eagleton, Terry. 'Capitalism, Modernism and Postmodernism'. *New Left Review* 152 (1985): 60–73.

Fabo, Andy. 'Nationalism, Internationalism, Regionalism'. *C Magazine* 3 (Autumn 1984): 71–3.

Fenton, Terry, and Karen Wilkin. *Modern Painting in Canada: Major Movements in Twentieth Century Canadian Art*. Edmonton: Hurtig, 1978.

Ferguson, Bruce, and Sandy Nairne. *The Impossible Self*. Winnipeg: Winnipeg Art Gallery, 1988. Exhibition Catalogue.

Fleming, Marie. *Murray Favro: A Retrospective*. Toronto: Art Gallery of Ontario, 1983. Exhibition Catalogue.

Fokkema, Douwe, and Hans Bertens, eds. *Approaching Postmodernism*. Amsterdam/Philadelphia: John Benjamins, 1986.

Foucault, Michel. *The Archaeology of Knowledge*. Trans. A.M. Sheridan Smith. New York: Harper and Row, 1972.

_____. 'What is an Author?' Trans. Josué V. Harari. In *The Foucault Reader*, pp. 101–20. Ed. Paul Rabinow. New York: Pantheon, 1984.

Freud, Sigmund. 'Screen Memories' (1899). In *The Freud Reader*, pp. 117–26. Ed. Peter Gay. New York: W.W. Norton, 1989.

_____. 'The Uncanny' (1919). *The Pelican Freud Library*. Trans. James Strachey. Vol 14, pp. 339-76. Harmondsworth: Penguin, 1985.

Fried, Michael. 'How Modernism Works: A Response to T.J. Clark'. *Critical Inquiry* 9, 1 (Sept. 1982): 217-34.

_____. 'Painting Memories: On the Containment of the Past in Baudelaire and Manet'. *Critical Inquiry* 10, 3 (March 1984): 510-42.

Gale, Peggy. 'Tom Sherman: There's something perverse about this relationship'. *Parachute* 58 (April-June 1990): 24-7.

General Idea. *General Idea: 1968-1984*. Toronto: Art Gallery of Ontario, 1984.

Goodman, Nelson. *Ways of Worldmaking*. Indianapolis: Hackett, 1978.

Gosselin, Marcel. 'Artist's Statement'. 10 May 1988.

_____. *Delta*. Saint-Boniface, Manitoba: Les Editions du Blé, 1986.

Griffiths, John. 'Deconstruction Deconstructed'. *The New Modernism: Deconstructionist Tendencies in Art*, pp. 9-18. London: Academy Editions, 1988.

Hume, Vern. 'Another Look at the Plot for a Western'. *Video Guide* 9, 1 (Oct. 1987): 6-7.

Hutcheon, Linda. *A Poetics of Postmodernism: History, Theory, Fiction*. New York and London: Routledge, 1988.

Huyssen, Andreas. *After the Great Divide: Modernism, Mass Culture, Postmodernism*. Bloomington and Indianapolis: Indiana University Press, 1986.

Jameson, Fredric. 'Postmodernism, or the Cultural Logic of Late Capitalism'. *New Left Review* 146 (July-Aug. 1984): 53-92.

_____. 'Postmodernism and Utopia'. *Utopia Post Utopia: Configurations of Nature and Culture in Recent Sculpture and Photography*, pp. 11-32. Boston: Institute of Contemporary Art, 1988.

Jauran et les premières plasticiens. Montréal: Musée des arts contemporaines, 1977. Exhibition Catalogue.

Joosten, J. and Robert Welsh, trans., eds, *Two Mondrian Sketchbooks*. Amsterdam: Meulenhoff International, 1969.

Kaplan, E. Ann, ed. *Postmodernism and its Discontents: Theories, Practices*. London and New York: Verso, 1988.

Kundera, Milan. *The Book of Laughter and Forgetting*. Trans. Michael Henry Heim. Harmondsworth: Penguin, 1981.

Kuspit, Donald. 'The Unhappy Consciousness of Modernism'. *Artforum* (Jan. 1981): 53-7.

Lacan, Jacques. *The Four Fundamental Concepts of Psycho-Analysis.* Ed. Jacques-Alain Miller, trans. Alan Sheridan. New York: W.W. Norton, 1977.

Lowenthal, David. *The Past is a Foreign Country.* Cambridge: Cambridge University Press, 1985.

Ludlow, Greg. 'Interview'. *Greg Ludlow: Constructed Paintings.* The Art Gallery of Windsor, 1985.

Lyotard, Jean-François. 'Answering the Question: What is Postmodernism?' Trans. Régis Durand. In Lyotard, *The Postmodern Condition: A Report on Knowledge.* Minneapolis: University of Minnesota Press, 1984.

McConathy, Dale. 'CORRIDART: instant archaeology in Montréal'. *artscanada* July/Aug. 1976: 36-53.

Molinari, Guido. *Guido Molinari: Écrits sur l'art (1954-1975).* Ed. Pierre Théberge. Ottawa: Galerie nationale du Canada, 1976.

Mondrian, Piet. *The New Art—The New Life: The Collected Writings of Piet Mondrian.* Ed., trans. Harry Holtzman, Martin S. James. Boston: G.K. Hall, 1986.

Monk, Philip. *Struggles with the Image: Essays in Art Criticism.* Toronto: YYZ Books, 1988.

Nemiroff, Diana. *Melvin Charney, Krzysztof Wodiczko: Canada. XLII Biennale Di Venezia 1986.* Ottawa: National Gallery of Canada, 1986.

Norris, Christopher. 'Deconstruction, Postmodernism and the Visual Arts'. London: Academy Editions, 1988: 7-31.

Owens, Craig. 'The Allegorical Impulse: Toward a Theory of Postmodernism'. *October* 12 (Spring 1980): 67-86.

Plato. *Collected Dialogues.* Ed. Edith Hamilton and Huntington Cairns. Princeton: Princeton University Press, 1973.

Pollock, Griselda. *Vision and Difference: Femininity, Feminism and the Histories of Art.* New York and London: Routledge, 1988.

Pontbriand, Chantal. *The Historical Ruse / La Ruse Historique: Art In Montréal.* Toronto: The Power Plant, 1988.

Preziosi, Donald. *Rethinking Art History: Mediatations on a Coy Science.* New Haven and London: Yale University Press, 1989.

Smith, Paul. *Discerning the Subject.* Theory and History of Literature, vol. 55. Minneapolis: University of Minnesota Press, 1988.

Smolik, Noemi. Review of 'Focus: Canadian Art from 1960 to 1985'. *Canadian Art* Spring 1987, 92-3.

Teitelbaum, Matthew and Peter White. *Joe Fafard: Cows and Other Luminaries 1977-1987*. Saskatoon and Regina: Mendel and Dunlop Art Galleries, 1987. Exhibition Catalogue.

Terdiman, Richard. 'Deconstructing Memory: On Representing the Past and Theorizing Culture in France Since the Revolution'. *Diacritics* Winter 1985: 13–36.

Théberge, Pierre. *Guido Molinari*. Ottawa: National Gallery of Canada, 1976. Exhibition Catalogue.

Tod, Joanne. 'Talk' in a session entitled 'Painting and the Context of Feminism'. Universities Art Association of Canada annual meeting, Halifax, 1987.

_____. Conversation with Mark Cheetham, Toronto, Oct. 1989.

Tousignant, Claude. 'Quelques précisions essentielles'. *Conférences J.A. De Sève*, 11–12, pp. 81-4. Montréal: Université de Montréal, 1971.

Wallace, Ian. 'Jeff Wall's Transparencies'. *Jeff Wall: Transparencies*. London: ICA, 1984. No pagination.

Warnock, Mary. *Memory*. London: Faber and Faber, 1987.

Wedman, Neil. 'Death Ray'. Unpublished ms., no pagination, 1987.

Welsh, 'Mondrian and Theosophy'. *Piet Mondrian: Centennial Exhibition*. New York: Guggenheim Museum, 1971.

Wittgenstein, Ludwig. *Philosophical Investigations*. Trans. G.E.M. Anscombe. England: Basil Blackwell and Mott, 1958.

Wodiczko, Krzysztof. 'Public Projections'. *October* 38 (Fall 1986): 3-20.

Yates, Frances A. *The Art of Memory*. Harmondsworth: Peregrine, 1969.

AFTERWORD

POSTMODERNISM'S IRONIC PARADOXES: POLITICS AND ART

by Linda Hutcheon

A Canadian postmodern scene: five photographs, topped and underlined with a verbal text. The central image is a soaring view upwards of the Trans-America building in San Francisco, its formal and cultural associations probably equally divided between American-ness/modernity and phallic power/presence. A large Marlboro cigarette billboard adds to this a sign of consumer capitalism. The photograph on the left appears to represent a naked woman in a pose suggesting—especially in its contiguity with the phallic building next to it—sensual abandonment. Ironically, this is no living, flesh-and-blood sensuous woman, but a stone statue—actually part of a bench in Mount Pleasant Cemetery in Toronto. On the other side of the central image is a representation of two more stone figures, one male and one female, captured in a pose that suggests arrested motion. But death is still present—and not only because of the proximity of that cemetery bench: this is a photograph of part of the

109

Highlights – Shadows

to see the rules of your expression become the laws of an exchange

27 Geoff Miles,
excerpt from *Foreign Relations* (1987)

Toronto War Memorial for South Africa. Race and colonialism are covertly added to gender as implied concerns; war and death are overtly used ironically to 'frame' American capitalist power. The two outer and smaller photographs—one of a male and one of a female—act formally as quotation marks that signal sexual difference and, more significantly, sexual separation in an Americanized consumerist world of death and destruction. The texts that accompany these images are small, forcing the viewer to approach the work very closely and thus enter the space—visual and cultural—of those images. Above them is printed, in capital letters, the words 'HIGHLIGHTS — SHADOWS'. This is, on one level, a descriptive heading, sitting as it does atop photographs which show considerable play with chiaroscuro and thus foreground, on another level, the technical mechanism of black and white photography in a very self-reflexive way. Beneath the images are the oddly phrased words: 'To see the rules of your expression become the laws of an exchange.' The ironies here are acute: we can see *no* facial expressions full-on (all are in shadow or turned away—partially or totally—from the viewer) except that of the Marlboro man in the central advertisement image, the image of the 'laws' of American capitalist 'exchange'. The combination of the resolutely political and the self-consciously aesthetic here in the third panel of Canadian photographer Geoff Miles's pointedly entitled *Foreign Relations* (1987; Plate 27) is what I think best defines postmodernism today.

Roland Barthes once claimed that it is impossible to represent the political, for it resists all mimetic copying. Rather, he wrote, 'where politics begins is where imitation ceases' (*Roland Barthes*, 154). This is precisely where the self-reflexive, parodic art of the postmodern comes in, underlining in its ironic way the realization that all cultural forms of representation—literary, visual, aural—in high art or in the mass media are ideologically grounded, that they cannot avoid involvement with social and political relations and apparatuses (Burgin, *Between*, 55). It is not that postmodernist art necessarily represents politics; instead, it unavoidably foregrounds what Victor Burgin calls the 'politics of representation' (*Between*, 85). This is as true of the fiction of Michael Ondaatje, Robert Kroetsch, Margaret Atwood, or Timothy Findley as it is of the art of Joyce Wieland, Evergon, or Carole Condé and Karl Beveridge.

Umberto Eco considers postmodern 'the orientation of anyone who has learned the lesson of Foucault, i.e., that power is not something unitary that exists outside us' (in Rosso, 4). He might well have added to this (as others have) the lessons learned from Derrida about textuality and deferral, or from Vattimo and Lyotard about intellectual mastery and its limits. In other words, it is difficult to separate the politicizing impulse of

Standing above it all,
he sensed the power
of his position.

The text needs its shadow!
This shadow is a bit of ideology,
a bit of representation, a bit of subject.

28 Geoff Miles,
excerpt from *The Trapper's Pleasure of the Text* (1985)

postmodern art from the deconstructing impulse of what we have labelled 'poststructuralist' theory. For example, Roland Barthes's playfully serious expositions of the duplicitous role of linguistic and visual codes in both mythologizing and de-mythologizing, in both controlling and subverting the *doxa*—the received opinions—of cultural consensus have been important in helping artists negotiate the space between the verbal and the pictorial as well as between the political/theoretical and the aesthetic. In this book, Jane Buyers cites Barthes in her *Language/Possession* (1988), and Geoff Miles, once again, in *The Trapper's Pleasure of the Text* (1985; Plate 28), also uses the same critic's words to play off the complexities of texual language against the deceptive, seeming transparency of the photographic image. Both Buyers and Miles do this in part self-reflexively to engage the art historical memory: *Language/Possession* recalls a work by the Italian Renaissance artist Simone Martini, and *Trapper's Pleasure* invokes documentary street photography as well as Cartier Bresson's 'decisive moment' shots. Here the postmodernly ironic street scene decisively 'captures' only the shadow of the 'trapping' photographer himself.

Although there has been much debate on this issue, I still believe that the inseparability of poststructuralist theory and postmodern art today can be seen not only in these particular works but in the more general way in which both artists and critic/theorists write about their 'discourses'. By the very choice of this term they signal their awareness of the inescapably political contexts in which they work. When 'discourse' is defined as the 'system of relations between parties engaged in communicative activity' (Sekula, 'Invention', 84), it points to such a politically un-innocent thing as the expectation of shared meaning, and it does so unavoidably within a dynamic social context that acknowledges the inevitability of the existence of power relations in any social activity—including art. As one theorist of postmodernism has put it: 'Postmodern aesthetic experimentation should be viewed as having an irreducible political dimension. It is inextricably bound up with a critique of domination' (Wellbery, 235).

Yet it must also be admitted from the start that this is a very strange kind of critique, one bound up with its own *complicity* with power and domination, one that acknowledges that it cannot escape implication in that which it nevertheless still wants to analyse and even undermine: capitalism, liberal humanism, patriarchy, or any other cultural dominant of our time and place. The ambiguities of such a position are translated into both the content and the form of postmodern art, which thus at once purveys and challenges ideology—but always self-consciously. In many contemporary art forms—painting, video, film, photography, sculpture, and so on—there are works that engage in these postmodern ambiguities largely

through their problematizing of the issue of representation—that is, through their de-naturalizing of the 'natural' or what we take as 'given' in the images by which we recognize, and create, ourselves in society. These 'representational' (often figurative) arts share an aesthetic history that is firmly rooted in realist representation but that, especially since their twentieth-century reinterpretation in modernist, formalist terms, now seem to be in a position to confront both their documentary and their formalist impulses. This is the confrontation I see as postmodernist: where some form of documentary historicity meets formalist self-reflexivity and parody. At this juncture, the study of representation becomes not the study of mimetic mirroring or subjective projecting, but an exploration of the way in which images structure how we see ourselves and how we construct our notions of the self in the present and in the past. This is how postmodern memory works.

Postmodernism in Canadian art has been called 'a challenge that has displaced style by content, rejected the values and expectations of modernist art, and engaged itself directly with political and social issues, with communication, with self-identity, and the binding and devisive natures of human relationships' (Burnett and Schiff, 247). Generally speaking, the postmodern also appears to coincide with a greater cultural awareness of the existence and power of systems of representation that do not *reflect* society so much as *grant meaning and value* within a particular society. If we believe current social scientific theory, there is a paradox involved in this awareness, however. On the one hand, there is a sense that in the Western world we can never get out from under the weight of a long tradition of visual representations. On the other hand, we also seem to be losing faith in the inexhaustibility and power of these existing representations. And parody is often the postmodern form that this paradox takes. By both using and abusing the general conventions and specific forms of representation, postmodern parodic art manages to de-naturalize the 'natural' in them, giving what Rosalind Krauss has called the strange sense of 'loosening the glue by which labels used to adhere to the products of conventions' (121). I am not referring here to the kind of ahistorical kitsch seen in some Toronto restaurants or at the West Edmonton Mall; rather the postmodern—playful but serious—parody in the art of a group like General Idea is one of the important means by which our culture can express both its social and aesthetic dilemmas—and the two are not unrelated. In *The Unveiling of the Cornucopia* (Plate 2), General Idea both inscribes and subverts a number of our inherited notions about art and its role in society. The would-be fresco fragments conjure up a complex of ideas clustered around the Romantic aesthetic notions of origin and

originality. Here history—or cultural memory—appears to offer art as a component in some mysterious ritual, separate and separated from the social. Yet by making the figures involved into poodles, General Idea at once undercuts the desire for both mystery and Romantic authenticity and provokes a postmodern critique of art's role in today's society, bereft of both desires, awash in consumer capitalist values. These values are what their *1984 Miss General Idea Pageant* and *Pavilion* projects brought to the fore so very powerfully, if playfully, as we shall see later.

The politics of representation cannot often be separated from the representation of politics (of many kinds) in postmodern art. Catharine Stimpson has noted:

> Like every great word, 'representation/s' is a stew. A scrambled menu, it serves up several meanings at once. For a representation can be an image— visual, verbal, or aural. . . . A representation can also be a narrative, a sequence of images and ideas. . . . Or, a representation can be the product of ideology, that vast scheme for showing forth the world and justifying its dealings. (223)

Postmodern representation is self-consciously all of these and more— image, narrative, product (and producer) of ideology. It is a truism of sociology and cultural studies today to say that life in the postmodern world of the West is utterly mediated by representations; that our age of satellites and computers has gone well beyond Benjamin's 'Age of Mechanical Reproduction' with its particular epistemological and aesthetic consequences and moved into a state of crisis in representation (Benhabib). Nevertheless, in art critical circles there is still a tendency to see postmodern theory and practice as simply replacing representation with surface textuality or as denying our 'enmeshment in representation' (Arac, 295), even though much postmodern thought has explicitly refuted these views: for instance, Derrida's argument about the inescapability of the logic of representation and Foucault's various problematizations, though never repudiations, of our traditional modes of representation in our discourses of knowledge.

In one sense the very word 'representation' unavoidably suggests some given which the act of representing in some way duplicates. This is normally considered the realm of mimesis. Yet by simply making representation into an issue once again, postmodernism challenges our mimetic assumptions about representation (in any of its "scrambled menu" of meanings), especially assumptions about its transparency and common-sense naturalness. In the background is Louis Althusser's much-cited notion of ideology as a system of representation and as an

unavoidable part of every social totality (231-2). In the foreground is Jean Baudrillard's theory of the 'simulacrum'. In *Simulations* Baudrillard argues that today the mass media have neutralized reality in stages: first *reflecting* it; then *masking* and perverting it; next, *masking its absence*; and finally producing in its stead the *simulacrum* of the real, the destruction of meaning and of all relation to reality. Baudrillard's model has come under attack for the metaphysical idealism of its view of the 'real', for its nostalgia for a pre-mass-media authenticity, and for its apocalyptic nihilism. But there is an even more basic objection to his assumption that it is (or was) ever possible to have unmediated access to reality: have we ever known the 'real' except through representations? We can certainly see, hear, feel, smell and touch it, but do we *know* it—in the sense that we give meaning to it? In Lisa Tickner's succinct terms, the real is '*enabled to mean* through systems of signs organized into discourses in the world' (19). This is where the politics of representation enters for, according to Althusser, ideology is a production of representations (231-2). Our common-sense presuppositions about the 'real' depend upon how that 'real' is described, how it is put into discourse and interpreted. There is nothing natural about the 'real'—even before the existence of the mass media.

This said, it is also the case that—however naïve his views that innocent, stable representation was once possible—Baudrillard's notion of the simulacrum has been immensely influential in the debates on postmodernism. Witness the unacknowledged but no less evident debt to it in Fredric Jameson's own version of pre-mass-media nostalgia: 'In the form of the logic of the image or the spectacle of the simulacrum, everything has become "cultural" in some sense. A whole new house of mirrors of visual replication and of textual reproduction has replaced the older stable reality of reference and of the non-cultural "real"' (42). What postmodern theory and practice together suggest is that everything always was 'cultural', at least in the sense that everything always was—and is—mediated by representations. They suggest too that notions of truth, reference, and the non-cultural 'real' have not 'ceased to exist' (Baudrillard, 6) but that they are no longer unproblematic issues, assumed to be self-evident and self-justifying. The postmodern, as I have been defining it here, is not a degeneration into 'hyperreality' but a questioning of what reality can mean and how we can come to know it. It is not that representation now dominates or effaces the referent, but that it now self-consciously acknowledges its existence as representation—that is, as interpreting (and indeed, as creating) its referent, not as offering direct and immediate access to it.

This is not to say that what Jameson calls the 'older logic of the referent (or realism)' (43) is not historically important to postmodernist represen-

tation. In fact, many postmodern strategies are premised on a challenge to the realist notion of representation that presumes the transparency of the medium and thus the direct and 'natural' link between sign and referent. Of course, modernist art (in all its forms) challenged this notion as well, but it did so deliberately to the detriment of the referent, that is, by emphasizing the opacity of the medium and the self-sufficiency of the signifying system. What postmodernism does is to de-naturalize both realism's transparency and modernism's reflexive response, while retaining (in its complicitously critical way) the historically attested power of both. This is the ambivalent politics of postmodern representation that Allyson Clay's *Lure* (Plate 7) deploys so effectively in relation to the purism of modernism.

With the problematizing and de-naturalizing of both realist reference and modernist autonomy, postmodern representation opens up other possible relations between art and the world. Gone is what Benjamin called the 'aura' of art as original, authentic, unique, and with it go all the taboos against textual strategies that rely on the appropriation and parody of already existing representations. Think of what happens when a contemporary Canadian artist parodically inserts his own face within the representation of a famous modernist, as does Chris Cran in *Self-Portrait as Max Beckmann*. What happens is that memory is at *work*, and at work effectively: the history of representation itself becomes a valid subject of art—and not just its history as high art. The borders between high art and mass or popular culture and those between the discourses of art and the discourses of the world are regularly crossed in postmodern theory and practice. But it must be admitted that this crossing is rarely undertaken without considerable border tensions.

The appropriation of various forms of mass-media representation by postmodern artists like Bruce Barber has come under attack by the (still largely modernist) art establishment. Yet others see this as a necessary strategy of 'regenerative iconography' (Peterson, 7), as a recycling—in the ecological sense of breaking down and recasting images to address a contemporary society that is in danger of losing its cultural memory in its drive toward novelty. This conjunction of the political/social and the self-reflexively aesthetic—of the outward- and the inward-directed—defines the postmodern as operating both against and within the sphere of influence of the realist, romantic, and modernist pasts. And Andy Fabo's *Craft of the Contaminated*, as Mark Cheetham has discussed it, is a good example of how such parodic recycling can actually make memory into a political tool. The fact that the parodied work—Géricault's *Raft of the Medusa*—has been interpreted allegorically as both a historical reminder and a political

statement alerts the viewer of Fabo's painting to seek historico-political allegory as well. And indeed the items on this crafty raft do suggest such a reading: a Canadian flag, a teepee, a landscape by Lawren Harris of the Group of Seven. Part of Fabo's 'craft' as a Canadian painter, perhaps, is to come to terms not only with European high art (Géricault) but with Canadian cultural representations as well—no matter how historically repressed (that of the native peoples), no matter how clichéd (the flag) or aesthetically burdensome (the Group of Seven's legacy). Does the Canadian content here also 'contaminate' European high-art representation?

But it is not always nationality that Fabo's postmodern parody allegorizes. His *Laocoön Revisited* (1981) is a painted parody of that famous Roman statue, inspired by Greek sculpture—as well as of Lessing's Romantic fascination with it. The men represented, however, bear certain specific semiotic signs of 'gayness' in their appearance. The implied sexuality of the original statue is made overt in two of the males' erect members. The entwining snake here takes on complex and diverse meanings: it is unmistakably phallic, thereby giving a new interpretation to the forbidden knowledge of Eden's serpent; but it also comes to allegorize the binding forces—legal and moral—that society uses to constrain gay men.

This issue of the representation of gay males takes us back to *The Craft of the Contaminated*, for, in our society today, the notion of 'contamination' is difficult to disassociate from AIDS. Certainly Fabo's recent work would support such an interpretation. Significantly, however, perhaps in order to address our society more directly and more powerfully, Fabo has moved from painted parodies of European high art to paintings used in video form: his 1989 *Survival of the Delirious*, a video about those who live with and die from AIDS, is a piece made in collaboration with Toronto video artist Michael Balser. Fabo represents AIDS through the painted metaphor of the Cree demon, the Windigo. Canadian native art and narrative here replace the art of the European past in a complicated political statement about both Canadian post-colonialism and the shared oppression of natives and gays in this society.

This complexity of political message, deriving directly from aesthetic parody operating on every level from that of titles to composition and content, often means that postmodern representational strategies refuse to stay neatly within accepted generic conventions and traditions. This art frequently deploys hybrid forms and seemingly mutually contradictory tactics, and therefore always frustrates critical attempts (including this one) to systematize them, to order them with an eye to control and mastery—that is, to totalize them. Roland Barthes once asked: 'Is it not the characteristic of reality to be *unmasterable*? And is it not the characteris-

tic of system to *master* it? What then, confronting reality, can one do who rejects mastery?' (*Roland Barthes*, 172). Postmodern representation itself contests mastery and totalization, often by unmasking both their powers and their limitations. We watch the process of what Foucault once called the interrogating of limits that is now replacing the search for totality. On the level of representation, this postmodern questioning overlaps with similarly pointed challenges by those working, for example, in post-colonial or feminist or Marxist contexts. How is the 'other' represented in, say, imperialist or patriarchal or capitalist discourses? However represented, it differs from its portrayal in works like those of Fabo or Barber. Postmodern thought 'refuses to turn the Other into the Same' (During, 33).

It is this kind of refusal that has contributed to the now standard view of the postmodern as being too dispersed, too appreciative of difference, or as lacking an ordered or coherent vision of 'truth': 'To the postmodernist mind, everything is empty at the center. Our vision is not integrated— and it lacks form and definition' (Gablik, 17). Actually that centre is not so much empty as called into question, interrogated as to its power and its politics. And if the notion of centre—be it seen in terms of 'Man' (as in Alice Mansell's punning *Manoeuvre*, Plate 14) or 'Truth' or whatever—is challenged in postmodernism, what happens to the idea of the 'centred' subjectivity, the subject of representation? In Stimpson's terms, 'the theory that representational machineries were reality's synonyms, not a window (often cracked) onto reality, eroded the immediate security of another lovely gift of Western humanism: the belief in a conscious self that generates texts, meanings, and a substantial identity' (236). That sense of the coherent, continuous, autonomous and free subject, as Foucault suggested in *The Order of Things*, is a historically conditioned and historically determined construct—and this is what the art in the second chapter of this book calls to our attention. Representational self-consciousness in works like Janice Gurney's *Screen* (Plate 13) points to a very postmodern awareness of both the nature and the historicity of our various discursive representations of the self. And it is not only the obvious psychoanalytic and poststructural theories that have helped engender this complex awareness. As we can see here, feminist theory and practice have problematized even poststructuralism's (unconsciously, perhaps, phallocentric) tendency to see the subject in apocalyptic terms of loss or dispersal: instead, they refuse to foreclose the question of identity. This refusal is undertaken in the name of the (different) histories of women: 'Because women have not had the same historical relation of identity to origin, institution, production, that men have had, women have not, I think, (collectively) felt burdened by too much Self, Ego, Cogito, etc.' (N. Miller,

106). It is the feminist need to inscribe first—and only then to subvert—
that I think has influenced most the complicitously critical postmodern
stand of underlining and undermining received notions of the subject.

In postmodern art, subjectivity is represented as something in process,
never fixed, never autonomous or outside history. It is always a gendered
subjectivity, but it also cannot be considered apart from class, race, ethnicity,
and sexual orientation. And it is usually textual self-reflexivity that para-
doxically calls these 'worldly' particularities to our attention by fore-
grounding the politics behind the dominant representations of the
self—and the 'other'—in visual images. To give an example from a related
medium, R. Murray Schafer's *Patria l: The Characteristics Man* is a theatrical/
operatic/rock/performance work that thematizes and actualizes the prob-
lematic nature of postmodern subjectivity. A silent, anonymous immigrant
('D.P.'), introduced to the audience as 'victim' (a large sign with this word
and an arrow follows him about the stage), seeks to define a self in a new and
hostile Canadian world that denies him his (non-English) speech, leaving
him only with the symbolic voice of the (ethnically coded) accordion. A
strategically placed wall of mirrors faces the audience at one point, prevent-
ing any self-distancing and any denial of complicity on our part.

While most art forms today can show this same kind of awareness of the
politics of representation, photography often seems to have chosen to do so
more blatantly than others. As a visual medium, it has a long history of
being both politically useful and politically suspect: think of Brecht, of
Benjamin, or of Heartfield's anti-Nazi photomontages. A recent show of
three Vancouver photographers (Arni Runar Haraldsson, Harold Ursuliak
and Michael Lawlor), called *A Linear Narration: Post Phallocentrism*, offered
examples of sophisticated satirical socio-political analyses of dominant
cultural representations (E. Miller). Lawlor's media-derived photomon-
tages are most reminiscent of Heartfield's in technique, if not in virulence:
Two Queens appropriates two already existing and familiar images, placing
together roughly torn-out pictures of Warhol's Marilyn Monroe and a
newspaper photo of Queen Elizabeth II. This conjunction suggests a partic-
ularly Canadian irony directed against our double colonialization: historical
(British royalty) and present-day (American media).

Photography today is one of the major forms of discourse 'through
which we are shown and show ourselves' (Corrigan, 13). Frequently,
what I would call postmodern photography foregrounds the notion of
ideology as representation (Althusser, 231) by appropriating recognizable
images from that particular omnipresent visual discourse, almost as an act
of retaliation for its (unacknowledged) politics (Burgin, *Between*, 54), its
(unacknowledged) constructing of our images of self and world. Photog-

raphy, precisely because of its mass-media ubiquity, allows what are considered high-art representations—like those of Nigel Scott or Jeff Wall—to speak to and against those of the more visible vernacular, to 'catch the seduction' (Foster, 68) of those conventional images.

What is common to all postmodern challenges to convention is their exploitation of the power of that convention and their reliance on the viewers' knowledge of its particulars. In most cases, this reliance does not necessarily lead to elitist exclusion because the convention being evoked has usually become part of the common representational vocabulary of newspapers, magazines, or advertising—even if its history is more extensive. For example, *Maillot Noir et Blanc* (1986; Plate 29), by Nigel Scott, offers a model in a bathing suit, striking a pose that suggests she is ready to dive, though a bathrobe hangs from her arms, which stretch out behind her. She stands on a pedestal against a (self-reflexively) ill-hung canvas backdrop. In this one image Scott openly contests a number of prevailing and obvious (male) representations of women: as inactive pin-up bathing beauty (this one is prepared to dive, wears a utilitarian bathing cap, and refuses the gaze of the viewer, looking and facing, instead, off to the left); as idealized passive female figuratively set on a pedestal; as capitalist symbol (the Rolls Royce Winged Victory's silhouette appears as a bathrobe-dropping swimmer). Photographs like this address their viewers' memory and knowledge of the common visual vernacular of twentieth-century Canadian life.

In the work of Bruce Barber, existing photographic representations—such as those of the Vietnam war—are appropriated and are effective precisely because they are loaded with pre-existing meaning. They are placed in new and ironic contexts to bring about that typically postmodern complicitous critique: while exploiting the power of familiar images, this art also works to de-naturalize them, making 'visible the invisible mechanisms whereby these images secure their putative transparency' (Owens, 21), and bringing to the fore their politics, that is, the interests in which they operate and the power they wield—or fail to wield through cultural amnesia (Folland, 60). Both any (realist) documentary value and any formalist (modernist) pleasure such an appropriating practice might invoke in *Nam* are inscribed, even as they are undercut. So too is any Romantic notion of individuality or authenticity—for the work or the artist. But this particular notion has always been somewhat problematic for photography as a mechanically reproductive medium (Solomon-Godeau, 'Photography', 80), and this technological aspect has other implications as well. Commentators as diverse as Annette Kuhn (26-7), Roland Barthes (*Camera*, 87-8), and Susan Sontag (179) have remarked on photography's ambivalences: it is

29 Nigel Scott,
Maillot Noir et Blanc (1986)

in no way innocent of cultural formation (or of forming culture), yet it is in a very physical sense technically tied to the real, or at least to the visual and the actual. And this paradox is what the postmodern use of this medium exposes: even as it exploits the ideology of the 'visible as evidence' (Kuhn, 27), it unmasks what might be *the* major photographic code—the one that pretends to look uncoded and 'natural'.

The postmodern photographer is, in Hal Foster's terms of reference, more the manipulator of signs than the producer of an art object; the viewer is the active decoder of a message, not the passive consumer or even the rapt contemplator of artistic beauty. The difference is one of the politics of representation. However, postmodern photographs are often also overtly about the representation of politics. Carole Condé and Karl Beveridge's *No Immediate Threat* (1986; Plate 30) is a photo-textual narrative series telling the story of the exposure to radiation hazards of Ontario nuclear power plant workers. No attempt is made here to achieve the traditional documentary illusion of transparency or of objectivity or even neutrality of representation. Nor is this an example of the passive 'victim photography' of the American documentary work commissioned in the 1930s by the Farm Securities Administration. The point of view here is that of the workers and the aim is not really to record working conditions but to agitate for their change. Instead of images of real workers on the job, Condé and Beveridge present photographs of manifestly 'staged' tableaux with artificial-looking props and actors stiffly posed like mannequins, in order to re-enact scenes recounted by the workers themselves (in interviews). Texts drawn from these accounts accompany the pictured scenes, in stark and ironic contrast to other incorporated texts and images presenting official government and industry statements about nuclear safety. This series has been shown not only in galleries (it has been purchased by the Art Gallery of Ontario) but in union halls, community centres, and libraries—in other words, in public sites that signal its social and political intent. The series' intense self-consciousness about its own *constructing* of images of historical actuality through flagrant artifice is what actually enables—not inhibits—such a politicization of representation. There is no transparency to either the images or the stories; there is only the clash of different representations and their politics.

As some commentators have argued, photography may legitimize and normalize existing power relations, in one sense, but it can clearly also be used against itself to de-naturalize that authority and power and to reveal how its representational strategies construct an 'imaginary economy' (Sekula, 'Reading', 115) that might warrant deconstructing. Of course, it is not only photography that both does and undoes this 'economy'. For

30 Carole Condé and Karl Beveridge,
one element from *No Immediate Threat* (1986)

instance, Stan Douglas uses multi-media installations to study representation in terms of the relations of culture to technology, especially film technology. He disassembles film into its constituent parts (sounds; stills projected as slides) in order to make opaque the supposed ability of film to be a transparent recording/representing of reality. As we have seen, General Idea has taken a different tack but one that also looks to this kind of politics of representation. Their *1984 Miss General Idea Pageant* made the high-art world into a beauty pageant, literalizing art's relation to what we today like to call 'displaced desire' and 'commodity acquisition.' In the process, they also managed to problematize our culture's patriarchal notions of the erotic and of sexual 'possession" in relation to capitalist values.

It has frequently been women artists, however, who have most pointedly engaged in the politicized critique of gender representations. Sheila Ayearst's *Three Minutes* (Plate 1) uses an ironic but reverential parody of a famous Rembrandt painting to lay bare the patriarchal discourses that determine the representation of the human body—and brain—in history: science (Dr Deijman's anatomy lesson to male students), medicine (the autopsy report), art (Rembrandt). Joanne Tod's *Self Portrait* (1982) deploys a series of multiple ironies to tease out a political message about feminine subjectivity as represented in North American culture. The first subverting irony of the work is that this is *not* a self-portrait of Joanne Tod; it is an image copied from an ad in a fashion magazine of an elegant woman in an evening dress, standing in a dramatic, if stagey, pose. The setting is not Canadian, but ur-American: the Lincoln Memorial in Washington, DC, with the phallic Washington Monument asserting its presence strongly. Yet in another sense this is an ironically pointed portrait of how the gendered self is portrayed—and constructed—for and by women (and Canadians?) themselves. As in advertising copy, there is a text inscribed here on the image, but this one appears strangely incongruous: 'neath my arm / is the color of Russell's Subaru.' Is this an anti-Yuppie, anti-consumerist irony against people who define themselves by their possessions? Are the Japanese car and the American setting signals of the 'global village' of advertising—and therefore of the aptly termed 'multinational' capitalism of today? This very same painting is later reproduced in an even more obviously ironic context, hanging on a dining-room wall in *Self Portrait as Prostitute* (1983; Plate 31). Here the table is set for dinner, but no one is present: perhaps guests have not yet arrived; more likely, the absent woman is cooking it in the kitchen. The title here suggests that women have been 'prostituted' not only to fashion and advertising but to domesticity—all manifestations of patriarchal power and ideology.

31 Joanne Tod,
Self Portrait as Prostitute (1983)

Gay artists like Fabo address the structures and strictures of dominant representations of the male and the masculine in ways that recall feminist work on the social construction of Woman. Evergon is a Canadian photographer whose identity as a gay male is central to his work. For example, *1 Boy with Ingrown Tattoo* (1971) offers multiple parodic echoes of the art-historical tradition of male nudes—but with an ironic twist or two. Here is a youthful, well-built male posing in a natural setting in a way that recalls classical and Baroque portrayals of, for instance, St Sebastian (Hanna, 6). But ironic incongruencies at once both inscribe and disrupt this work of memory and also encode other signs of a homoerotic sexuality left only implicit in those theoretically religious representations. First, there is the tattoo—'ingrown', according to the title. Second, there is the facial expression of the young man: either sensual or sullen, or both. The third incongruent item is the underwear worn by the youth (pulled down around his thighs). Two very different iconographic memories come into play here: the conventions of soft-core pornography and—ironically modernized—the modesty-protecting loin-cloths that usually covered male genitals in high-art representations of otherwise naked men. Here the underwear serves no such purpose, as it is lowered to reveal all. Another level of sexual suggestiveness enters with the parodic recalling of Caravaggio's *Flagellation* in the boy's pose. Given the importance of that painter—in terms of both his sexuality and his lushly coloured and textured rendering of male figures—to Evergon's later large-format Polaroid photographs, this connection is not a gratuitous working of visual memory.

Gender and sexuality are two important politicized issues explicitly raised by postmodern Canadian art and by current feminist and gay criticism and theory. Class and race/ethnicity have also become prominent, if problematic, social notions addressed by postmodernism. Joanne Tod's *Reds on Green* (Plate 8) parodies colour field painting in particular and modernist formalism in general. But there is perhaps another politics operating here as well: a politics, literally, of colour. The Chinese communists are figured not only to engage the title's punning play on 'Reds' (on a green background), but also to raise the issue of race and colour in politics. In some of her work, representations of Asians and blacks replace women as symbols of 'otherness', in what is often considered Canada's generally homogeneous white (and patriarchal, capitalist) society. In *Allegro Furioso Ma Stereotypissimo* (1985), nine oriental female musicians are dwarfed by a giant pair of (male) hands bearing drumsticks. The unrealistic scale in an otherwise realist representation alerts viewers to allegorical and ironic possibilities. The 'allegro' of the title is obviously a musical term for a certain speed of playing, but its conjunction with 'furioso' may well be

meant to suggest Ariosto's *Orlando Furioso*, the comic Renaissance epic of male—and Caucasian—chivalry. But this 'allegro furioso' is said to be 'but most stereotypical', likely in both gendered and racial terms: Asians play Western musical instruments and do so these days with great accomplishment and flair; women play strings, woodwinds, and keyboard—relatively gentle and genteel instruments—while martial males stereotypically play loud drums, whose drumsticks resemble clubs about to beat the women players' heads. In works like *Infiltration* (1988), installed in the Pump Building of Toronto's Harris Water Filtration Plant for the 1988 *WaterWorks* show, a black male takes on the role of symbolic 'other', here trying to block out (with his hands over his ears) both the noise of the capitalist water-purifying industry (this is the noisiest room in the plant) and the represented notes of Handel's *Water Music*—both perhaps equally (and punningly) 'white noise'. This site-specific work plays iconographically in complex and often confusing ways with notions of social and racial infiltration. Similarly, in *Research and Development* (1986), Tod represents black men in a racially unmixed, black bar, drinking Black Label beer. The semiotic overdetermination of 'blackness' here is juxtaposed to two oddly inserted, separate paintings: one (on the upper left) portrays six white, middle-aged men in what appears to be a corporate boardroom where 'research and development' may not include thinking about racial equality of opportunity; the other (on the upper right) is a representation of New York's Guggenheim Museum. Have modern art and big business connived in marginalizing certain groups?

Tod's works are never simple and almost never provoke unambiguous interpretations. Is *Five to Twelve* (1988) a parody of the academic still life? It certainly represents, on one level, a legitimized (in both aesthetic and capitalist terms) image of beauty: a silver *objet d'art* featuring two female angels holding up a large silver bowl. But on the upper right third of the painting are four circles, acting almost as cut-outs, through which we see the eyes and lips of a black face. As Robert Mycroft asks, what are we to make of what he calls this 'Third World Presence' (87)? Is this 'a critique of commodification or a celebration of it?' Is it 'a silver samovar or a Molotov Cocktail' (87)? While clearly confusing, the work might suggest certain interpretive possibilities. The women portrayed on the silver *objet* are idealized beautiful images of winged womanhood, identical each to the other and thus symbolically unindividuated. Motionless and burdened with the bowl's weight, they are turned away from the viewer (at a 45-degree angle). While the viewer's eyes may safely and voyeuristically enjoy these female forms, the eyes of the black—likely male—showing through those four holes look back at the viewer, not at the art object or its

figured females at all. This confrontational staring back/staring down foregrounds both sexual and racial differences that were often ignored in art historical commentary before postmodernism.

This kind of art asks its viewers to question the processes by which we represent 'others' as well as our selves and our world, and to become aware of the means by which we literally *make* sense and *construct* order out of experience in our particular culture. We cannot avoid representation. We *can* try to avoid fixing our notions of it and assuming it to be transhistorical and transcultural. We can also study how representation legitimizes or privileges certain kinds of representation and knowledge, both today and in the past. We can put memory to work. The past for the postmodern is something with which we must come to terms, even if our resources for doing so may be limited. Postmodernism tries to understand present culture as the product of previous codings and representations. The representation of history becomes the history of representation too. Postmodern art acknowledges and accepts the challenge of tradition, however ironically: the history of representation cannot be escaped, but it can be both exploited and commented upon critically, often by means of parody. This kind of ironic recycling is one mode of problematizing and denaturalizing the conventions of representation in such a way that the politics of that act of representing is made manifest.

The work of Joanne Tod, Bruce Barber, and many other Canadian artists represented in this book moves outside the 'hermeneutic enclave of aesthetic self referencing' (Solomon-Godeau, 'Winning', 98) and into the social and cultural world, a world in which we are bombarded with images daily. They manage to point at once to the contingency of art and the primacy of social codes. They make the invisible become visible, the 'natural'—whether either modernist/formalist or realist/documentary— denaturalized. In Canadian art today, the documentary impulse of realism meets head-on the problematizing of reference begun by self-reflexive modernism. And the result is a new focus on the way in which art 'intersects and interacts with the social system in all its varied aspects' (Paoletti, 54), present and past. All representation has a politics; it also has a history. The conjunction of these two concerns in what some have called the New Art History (Rees and Borzello) has meant that issues such as gender, class, race, ethnicity and sexual orientation are now part of the discourse of the visual arts, as they are also of the literary ones today. Social history cannot be separated from the history of art: in both, memory is at work. There is no value-neutral, much less value-free place from which to represent—in any art form. And there never was.

WORKS CITED

Allen, Richard. 'Critical Theory and the Paradox of Modernist Discourse'. *Postmodern Screen* issue of *Screen* 28, 2 (1987): 69-85.

Althusser, Louis. *For Marx*. Trans. Ben Brewster. New York: Pantheon, 1969.

Arac, Jonathan. *Critical Genealogies: Historical Situations for Postmodern Literary Studies*. New York: Columbia University Press, 1987.

Barthes, Roland. *Mythologies*. Trans. Annette Lavers. London: Grenada, 1973.

———. *The Pleasure of the Text*. Trans. Richard Miller. New York: Hill & Wang, 1975.

———. *Roland Barthes by Roland Barthes*. Trans. Richard Howard. New York: Hill & Wang, 1977.

———. *Camera Lucida: Reflections on Photography*. Trans. Richard Howard. New York: Hill & Wang, 1977.

Baudrillard, Jean. *Simulations*. Trans. Paul Foss, Paul Patton, Philip Beitchman. New York: *Semiotext(e)*, Foreign Agents Series, 1983.

Benhabib, Seyla. 'Epistemologies of Postmodernism: A Rejoinder to Jean-François Lyotard'. *New German Critique* 33 (1984): 103-26.

Benjamin, Walter. 'The Work of Art in the Age of Mechanical Reproduction'. *In Illuminations*, pp. 217-51. Ed. Hannah Arendt. Trans. Harry Zohn. New York: Schocken, 1969.

Burgin, Victor. *Between*. Oxford: Blackwell, 1986.

———, ed. *Thinking Photography*. London: Macmillan, 1982.

Burnett, David and Marilyn Schiff. *Contemporary Canadian Art*. Edmonton: Hurtig; AGO, 1983.

Collins, James. 'Postmodernism and Cultural Practice: Redefining the Parameters'. *Postmodern Screen* issue of *Screen* 28.2 (1987): 11-26.

Corrigan, Philip. 'In/formation: A Short Organum for PhotoGraphWorking'. *Photo Communiqué* (Fall 1985): 12-17.

de Lauretis, Teresa, ed. *Feminist Studies/Critical Studies*. Bloomington: Indiana University Press, 1986.

Derrida, Jacques. 'Sending: On Representation.' Trans. Peter Caws and Mary Ann Caws. *Social Research* 49, 2 (1982): 294-326.

During, Simon. 'Postmodernism or Post-colonialism Today'. *Textual Practice* 1, 1 (1987): 32-47.

Folland, Tom. Rev. of Astrid Klein's exhibit at the Ydessa Gallery, Toronto. *Parachute* 50 (1988): 59-60.

Foster, Hal. *Recodings: Art, Spectacle, Cultural Politics*. Port Townsend, Wash.: Bay Press, 1985.

Foucault, Michel. *The Order of Things: An Archaeology of the Human Sciences*. New York: Pantheon, 1970.

Gablik, Suzi. *Has Modernism Failed?* London and New York: Thames & Hudson, 1984.

Hanna, Martha. *Evergon 1972-1987*. Ottawa: Canadian Museum of Contemporary Photography, 1988.

Harland, Richard. *Superstructuralism: The Philosophy of Structuralism and Post-Structuralism*. London and New York: Methuen, 1987.

Jameson, Fredric. 'Hans Haacke and the Cultural Logic of Postmodernism'. In Wallis (1986-7): 38-50.

Krauss, Rosalind. 'John Mason and Post-Modernist Sculpture: New Experience, New Words'. *Art in America* 67.3 (1979): 120-7.

Kuhn, Annette. *The Power of the Image: Essays on Representation and Sexuality*. London: Routledge & Kegan Paul, 1985.

Miller, Earl. Rev. of *A Linear Narration: Post Phallocentrism*. *Parachute* 49 (1987-8): 42.

Miller, Nancy K. "Changing the Subject: Authorship, Writing, and the Reader". In de Lauretis: 102-20.

Mycroft, Robert. 'Joanne Tod: Four Characteristic Works and Some Necessary Questions'. *Canadian Art* 5, 4 (1988): 84-7.

Owens, Craig. 'Representation, Appropriation & Power'. *Art in America* 70, 5 (1982): 9-21.

Paoletti, John T. 'Art'. In Trachtenberg: 53-79.

Peterson, Christian A. *Photographs Beget Photographs*. Minneapolis: Minneapolis Institute of Art, 1987.

Rees, A.L. and Frances Borzello, eds. *The New Art History*. London: Camden P., 1986.

Rosso, Stefano. 'A Correspondence with Umberto Eco'. Trans. Carolyn Springer. *boundary 2* 12, 1 (1983): 1-13.

Scherpe, Klaus R. 'Dramatization and De-dramatization of 'the End' : The Apocalyptic Consciousness of Modernity and Post-Modernity'. *Cultural Critique* 5 (1986-7): 95-129.

Sekula, Allan. 'On the Invention of Photographic Meaning'. In Burgin (1982): 84-109.

———. 'Reading an Archive'. In Wallis (1987): 114-27.

Solomon-Godeau, Abigail. 'Photography After Art Photography'. In Wallis (1984): 74-85.

———. 'Winning the Game When the Rules Have Been Changed: Art Photography and Postmodernism'. *Screen* 25, 6 (1984): 88-102.

Sontag, Susan. *On Photography*. New York: Farrar, Straus, Giroux, 1977.

Stimpson, Catharine R. 'Nancy Reagan Wears a Hat: Feminism and its Cultural Consensus'. *Critical Inquiry* 14, 2 (1988): 223-43.

Tickner, Lisa. 'Sexuality and/in Representation: Five British Artists'. *Difference: On Representation and Sexuality*, pp. 19-30. New York: New Museum of Contemporary Art, 1984.

Trachtenberg, Stanley, ed. *The Postmodern Moment: A Handbook of Contemporary Innovation in the Arts*. Westport, Conn.: Greenwood Press, 1985.

Wallis, Brian, ed. *Art After Modernism: Rethinking Representation*. New York: New Museum of Contemporary Art; Boston: Godine, 1984.

———, ed. *Hans Haacke: Unfinished Business*. New York: New Museum of Contemporary Art; Cambridge, Mass. and London: MIT Press, 1986-7.

———, ed. *Blasted Allegories: An Anthology of Writings by Contemporary Artists*. New York: New Museum of Contemporary Art; Cambridge, Mass.: MIT Press, 1987.

Wellbery, David E. 'Postmodernism in Europe: On Recent German Writing'. In Trachtenberg: 229-49.

NOTES ON ARTISTS

The following brief entries give more information on those Canadian artists discussed in detail in *Remembering Postmodernism*. These notes are intended as an orientation and do not claim completeness.

SHEILA AYEARST was born in Ottawa in 1951. She received a BFA degree from York University in 1977 and now works in Toronto. Recent solo exhibitions include 'Living on the Edge' (Galerie Powerhouse, Montréal, 1989) and 'Still Life' (Mercer Union, Toronto, 1988). She has participated in many group shows, including 'Beyond the Document: Extended Photography' (Forest City Gallery, London, 1989) and 'The Interpretation of Architecture' (YYZ, Toronto, 1986; catalogue by Andy Patton). Her interests in the appropriation of historical imagery and in photography are maintained in her most recent project, a series of large paintings and photos entitled 'The Verge', which are inspired by Jack Chambers's famous painting *401 Towards London*.

Sculptor, critic, and performance artist BRUCE BARBER was born in New Zealand in 1950 and has lived in Canada since 1976. In 1978 he received an MFA degree from the Nova Scotia College of Art and Design in Halifax, where he is currently Associate Professor and Director of Graduate Studies. Barber's extensive exhibition list shows the multidisciplinary nature of his interests. Since the early 1970s, he has executed bookworks, performances, videos, and sculpture/photo installations. Solo exhibits include 'Reading Room' (49th Parallel, New York, 1985) and 'Reading Room II' (Eyelevel Gallery, Halifax, and Artspace, Auckland, New Zealand, 1987). He has participated in 'Resistance—Anti-Baudrillard' (White Columns Gallery, New York) and in the touring exhibits 'Two Countries/Two Cities' (Halifax/ Lublin [Poland] exchange, 1988) and 'A Different War: Vietnam in Art' (Whatcom Museum, Bellingham, Washington, plus six tour venues in the US, 1989-92). Barber is the editor of *Essays on [Performance] and Cultural Politicisation* (*Open Letter* 5th series, nos 5, 6, Summer/Fall 1983) and author of *Low Culture versus High Culture: Cultural Hegemony and the Contestation of Power* (University of Minnesota Press, forthcoming).

Peterborough, Ontario artist CARL BEAM was born in West Bay, Ontario in 1943 and took his BFA from the University of Victoria in 1975. He has had solo shows at the Congress Centre in Ottawa (1990) and in many

private galleries in Canada as well as in New Mexico, and he has been part of group exhibitions across Canada.

SYLVIE BÉLANGER was born in Québec in 1951. She has earned a variety of university degrees: her MFA at York University, Toronto (1986), her BFA at Concordia University, Montréal (1983), a certificate in Education from the Université de Québec à Montréal in 1974, and an Honours BA in Religious Studies from the Université de Montréal (1973). She teaches in the Fine Arts department at the University of Windsor. Recent work has been exhibited in the Netherlands as well as in solo and group exhibitions in Ontario ('Continuous Fragments', Sarnia Public Art Gallery, 1988; 'I am Here', Mercer Union, Toronto, 1987; 'Time as a Minute', Artcite Gallery, Windsor; 'Garden (a collaborative work)' [with Anne Devitt], 1 01, Ottawa, 1989).

JANE BUYERS was born in Toronto in 1948 and works there as well as in Waterloo, Ontario, where she is a faculty member at the University of Waterloo. She graduated from York University with an Honours BA in Visual Arts in 1973. Her recent group exhibits include 'Water Works' (London Regional Art and Historical Museums, 1985) and 'The Interpretation of Architecture' (YYZ, Toronto, 1986; catalogue by Andy Patton). She has had solo shows across Canada and has been with the Garnet Press gallery in Toronto since 1988.

Toronto installation artist, sculptor, and photographer IAN CARR-HARRIS was born in Victoria in 1941. He was educated at Queen's University (BA 1963) and the University of Toronto (BLS 1964), and he is currently the Chair of the Department of Experimental Art at the Ontario College of Art in Toronto. Since the early 1970s, Carr-Harris has had a series of solo shows with the Carmen Lamanna Gallery in Toronto. He was part of the 'Vestiges of Empire' exhibition at the Camden Art Centre, London, in 1984 and of the 'Aurora Borealis' show in Montréal the following year. In 1987 he participated in 'Toronto: A Play of History (jeu d'histoire)' at The Power Plant in Toronto. Carr-Harris represented Canada at the 41st Venice Biennale in 1984. His work from 1971-7 was the focal point of a major exhibition curated by Philip Monk at the Art Gallery of Ontario in 1988.

Montréal was the birthplace of MELVIN CHARNEY (1935). He received his Master of Architecture degree from Yale University in 1959 and is now a Professor of Architecture at the Université de Montréal. He has exhibited in solo and group shows around the world and represented Canada at the 1986 Venice Biennale. Charney was recently commissioned to install new work at the Canadian Centre for Architecture in Montréal.

ALLYSON CLAY was born in 1953 in Vancouver, where she now works and teaches at Simon Fraser University. She was educated at the University of British Columbia (MFA 1985) and the Nova Scotia College of Art and Design (BFA 1980). She has curated exhibitions in Toronto, Vancouver, and Rome and has recently held solo shows at Artspeak in Vancouver (1988) and YYZ in Toronto (1987). Her work has been seen in numerous group exhibits across Canada. Clay currently exhibits with the Costin and Klintworth Gallery in Toronto.

CAROLE CONDÉ and KARL BEVERIDGE (born 1940 in Hamilton and 1945 in Ottawa) have worked together since 1975. They exhibit in a variety of contexts, from union halls to museums. Group exhibits include the 1976 Venice Biennale, 'Kunst mit Eigen-Sinn' (Museum Moderner Kunst, Vienna, 1985), and 'Voices of Dissent' (Painted Bride Art Center, Philadelphia, 1987). They have had solo exhibits at the Art Gallery of Ontario (1976), the Australian Centre for Photography (1982), the Institute for Contemporary Art in London (1983), and the Staatliche Kunsthalle in Berlin (1983), as well as many other venues.

Toronto photographer STAN DENNISTON was born in Victoria in 1953. In 1976 he graduated from the Department of Photo-Electric Arts at the Ontario College of Art. 'How to Read' was shown at YYZ in Toronto in 1988, and his 'Reminders' works have been seen throughout the country: Art Gallery of Greater Victoria, 1983 (catalogue by Jeanne Randolph); Canadian Museum of Contemporary Photography (touring), 1986; Art Gallery of Ontario 'Contact' exhibition (touring), 1987. In 1986, Denniston was part of the 'Songs of Experience' exhibition at the National Gallery of Canada and of 'The Interpretation of Architecture' at YYZ in Toronto.

EVERGON was born in Niagara Falls, Ontario, in 1946. He studied sculpture, drawing, printmaking, and painting as well as photography at Mount Allison University in New Brunswick. A summer course at the Rochester Institute of Technology led to his first experiments with hand-manipulated photo-related media. He graduated with an MFA in Photography from RIT in 1974 and taught at the Louisville School of Art in Kentucky and the Visual Arts Department at the University of Ottawa. Since 1986, with the support of a Canada Council grant, he has devoted his time to his photographic work, especially his large-format Polaroid photographs. In 1988 the Canadian Museum of Contemporary Photography held a retrospective of his work, 1971-87.

ANDY FABO was born in Calgary in 1953. In 1984 he was part of the 'Toronto Painting '84' exhibit at the Art Gallery of Ontario. Since then he has participated in group shows in New York, Zurich, Toronto, Ottawa, and Vancouver, among other places. His solo exhibitions include 'Western Flesh and Blood' (Garnet Press Gallery, Toronto, 1986), and 'A Landscape of Loss' (Forest City Gallery, London, Ont., 1987). He now shows regularly at Garnet Press and writes critical essays.

Sculptor JOE FAFARD was born in Ste Marthe, Saskatchewan, in 1942. He received his BFA in 1966 from the University of Manitoba and his MFA two years later from Pennsylvania State University. He now works in Pense, near Regina. Since 1970 his work has been seen in solo exhibitions across Canada, including the recent touring retrospective 'Joe Fafard: Cows and Other Luminaries 1977-1987'. He has been part of group exhibitions in Canada as well as in the US and Europe.

FASTWÜRMS is a collective of three Toronto artists, Kim Kozzi (born in Ottawa, 1955), Napoleon Brousseau (born in Ottawa, 1950), and Dai Skuse (born in Oldham, England, 1955). Among their recent solo exhibits are 'Arbor Vitae' (Forest City Gallery, London, 1988), 'Campo Vermi Veloci' (Canadian Cultural Centre, Rome, 1988), and 'Birch Girl Plaza' (Walter Phillips Gallery, Banff). Fastwürms has also been part of group shows in Italy and across Canada.

London, Ontario, artist MURRAY FAVRO was born in Huntsville, Ontario, in 1940. His numerous solo and group appearances through the 1970s and early 1980s culminated in 'Murray Favro: A Retrospective' (National Gallery of Canada [touring], 1984). In 1986 Favro was part of 'Focus— Canadian Art 1960-1985' in Cologne. He now exhibits regularly with the Carmen Lamanna Gallery in Toronto.

WYN GELEYNSE was born in the Netherlands in 1947 but moved to London, Ontario as a boy. He has had solo shows in New York, Ohio, Florida, Toronto, and Winnipeg and is now represented by Galerie Brenda Wallace in Montréal. His work was part of the 'On Track' exhibition of art and technology at the 1988 Olympic Arts Festival in Calgary and he represented Canada at the 1987 Sao Paulo Bienale.

The group GENERAL IDEA came together in Toronto in 1968. AA Bronson (Michael Tims) was born in Vancouver in 1946, Felix Partz (Ron Gabe) in 1945 in Winnipeg, and Jorge Zontal (Jorge Saia) in Parma, Italy, in 1944. Since 1970 they have had solo exhibits around the world, including 'The 1984 Miss General Idea Pavilion' (international tour, 1984-85).

Their group exhibitions include 'Dokumenta 7' (Kassel, 1982), 'O Kanada' (Berlin, 1983), 'An International Survey of Recent Painting and Sculpture' (Museum of Modern Art, New York, 1984), and 'Toronto: A Play of History (jeu d'histoire)' at The Power Plant in Toronto, 1987. General Idea is also well known for video work and for its writings in *Fuse* magazine.

Sculptor MARCEL GOSSELIN was born in 1948 in St Boniface, Manitoba. He took his honours BFA at the University of Manitoba in 1971 and now works in LaSalle, near Winnipeg. Recent solo exhibits include 'Fragments' (Mercer Union, Toronto, 1989) and 'Delta' (Winnipeg Art Gallery, 1986). Gosselin has participated in many group exhibitions as well, such as 'Diaries' (1987, touring) and the recent 'Contemporary Art in Manitoba' exhibition (touring). He recently won the Forks sculpture commission in Winnipeg.

ANGELA GRAUERHOLZ came to Canada from Germany, where she was born in Hamburg in 1952. Her photographs have been seen in solo exhibits at The Photographers Gallery, Saskatoon (1988), the Université de Sherbrooke (1987), the Stride Gallery in Calgary (1986), and most recently, at Art 45 in Montréal, where she exhibits regularly. She was part of the exhibition 'The Historical Ruse: Art in Montréal' (Toronto, The Power Plant, 1988).

Toronto artist JANICE GURNEY was born in Winnipeg in 1949. Over the past several years, she has had solo exhibits in Toronto (Wynick/Tuck Gallery), Oakville (Gairloch Gallery), and Montréal (Galerie Powerhouse) and has participated in many group exhibitions, including 'The Mothers of Invention' (McNeil Gallery, Philadelphia) and 'Identity/Identities' (Winnipeg Art Gallery). She has also published reviews and critical essays in many art magazines.

JAMELIE HASSAN was born in 1948 in London, Ontario, where she continues to live and work. Over the past fifteen or so years, she has produced over twenty installation works that have been seen in both solo (Mercer Union, Toronto; Eye Level Gallery Halifax; London Regional Art and Historical Musuems) and group contexts. She has shown in Cuba and gained special prominence as a participant in the 'Songs of Experience' exhibit at the National Gallery of Canada in 1986. She participated in the recent 'Commitment' exhibition at The Power Plant in Toronto (1990).

VERN HUME was born in Winnipeg and now works in Calgary, where he received his MFA in video in 1985. Exhibitions and screenings of his

videos have taken place at the Winnipeg Art Gallery ('Winnipeg Perspective: Video', 1985), at the Centre for Art Tapes, Halifax (1987), at the Ottawa SAW Gallery Canadian Video Festival in 1987, and at A Space in Toronto (1988), as well as at many other venues across the country.

London painter GREG LUDLOW was born in Toronto in 1954 and completed his MFA at the Nova Scotia College of Art and Design in 1981. He has had solo exhibits in London, Windsor, Oakville, and Toronto and has participated in various group shows since the mid-1970s.

WILLIAM MACDONNELL was born in Winnipeg in 1943 and received an MFA from the Nova Scotia College of Art and Design in 1979. Since 1985, he has held solo exhibits at the Stride Gallery in Calgary. He took part in the 'Encounters and Enquiries' exhibition at the London Regional Art and Historical Museums in 1987 and the 'Survey Alberta 88' show held in Calgary at the time of the 1988 Winter Olympics.

Born in Hanna, Alberta, in 1945, ALICE MANSELL received her MA from the University of British Columbia in 1970. She now works in London, where she is Chair of the Visual Arts Department at the University of Western Ontario. Solo exhibits of her painting have been seen in Bragg Creek, Alberta, at the Off Centre Centre in Calgary, and at the Betty Oliphant Theatre in Toronto. She has participated in faculty exhibitions in both Calgary and London as well as in 'Witness to Private Motives' at the Alberta College of Art in 1987. Mansell's critical essays have appeared in several Canadian publications.

GEOFF MILES, born in 1952, received his BA Honours in Photographic Arts at the Polytechnic of Central London in 1980. A theorist, critic, curator, lecturer, and reviewer as well, he has had numerous shows, both group and individual, in Canada, the United States, and England, and has received support from both the Ontario Arts Council and the Canada Council. He is currently completing a doctorate in Social and Political Thought at York University.

Painter GUIDO MOLINARI was born in Montréal in 1933, where he now works and where he teaches at Concordia University. He has had numerous solo and group shows since the early 1950s and was the recipient in 1980 of the Prix Borduas. He participated in the Paris Biennale in 1977 and was the subject of a touring retrospective mounted by the National Gallery of Canada in 1976. Recent group exhibitions include '10 Canadian Artists in the 1970s' (Art Gallery of Ontario and tour, 1980), and 'Stations' (Le Centre international d'art contemporain de Montréal,

1987). He has had solo shows recently at the 49th Parallel in New York (1987), the Vancouver Art Gallery (and tour, 1989–90), and the Wynick/ Tuck Gallery in Toronto (1990).

NIGEL SCOTT, a native of Jamaica, where he had worked in the photo department of an advertising agency, moved to Toronto in 1975 and made his name as one of Canada's most interesting fashion photographers, before moving to Paris a few years ago. His photographs have appeared in *Glamour*, the German *Miss Vogue*, Japan's *Fashion News* and, in the US, *Mademoiselle*. He was one of fourteen photographers chosen to shoot with the 20 x 24 Polaroid in conjunction with the Festival de la Foto de la Mode in Trouville, France, in 1989. His recent art photographs have been exhibited at the Jane Corkin Gallery in Toronto.

TOM SHERMAN was born in Manistree, Michigan, in 1947 and now works in Ottawa. His numerous videos have been seen across Canada in solo and group shows as well as on cable TV. He was part of the 'Canada Video' exhibit at the 39th Venice Biennale in 1980. Sherman also writes on video and culture.

BARBARA STEINMAN lives in Montréal and is a graduate of both McGill and Concordia Universities. She has been producing multi-media video installations since 1980 and has represented Canada at the Sao Paulo Bienale (1987) and in the Aperto exhibition at the 1988 Venice Biennale.

Toronto painter JOANNE TOD was born in Montréal in 1953 and educated at the Ontario College of Art. In addition to her annual exhibits at the Carmen Lamanna Gallery in Toronto, Tod has recently had solo shows at the Or Gallery, Vancouver (1989), the Forest City Gallery in London (1987), and the Art Gallery of Greater Victoria. She has been part of many trend-setting group exhibits: 'Late Capitalism' (Art Gallery at Harbourfront, Toronto, 1985), 'Songs of Experience' (National Gallery of Canada, 1986), 'Toronto: A Play of History (jeu d'histoire)' (The Power Plant, Toronto, 1987), 'Morality Tales: History painting in the 1980s' (Grey Gallery, New York, and US tour), and 'WaterWorks', at the R.C. Harris Water Filtration Plant in Toronto, 1988.

CLAUDE TOUSIGNANT was born in Montréal in 1932 and continues to work in that city. He has had solo exhibits nearly every year since the mid-1950s, including a retrospective toured by the National Gallery of Canada from 1973 to 1975. He has been part of group exhibits across Canada and in France (1980). In 1976 Tousignant was named an Officer of the Order of Canada; in 1989 he won the Prix Borduas.

NEIL WEDMAN works in Vancouver and shows with the Diane Farris Gallery. His most recent solo exhibits are 'Margery' (Diane Farris Gallery, 1990) and 'Death Ray' (Vancouver Art Gallery, 1987).

Sculptor ROBERT WIENS was born in Leamington, Ontario, in 1953 and now lives in Picton, Ontario. Recent solo exhibits include 'The Rip and the Little Boy' (Or Gallery, Vancouver, 1989), and 'Bush TV' (Forest City Gallery, London, 1989), as well as regular shows at the Carmen Lamanna Gallery in Toronto. His work has appeared in many important group exhibitions: 'Subjects and Objects' (MacDonald Stewart Art Centre, Guelph, 1985), 'Songs of Experience' (National Gallery of Canada, 1986), and 'Toronto: A Play of History (jeu d'histoire)' (The Power Plant, Toronto, 1987).

KRZYSZTOF WODICZKO was born in 1943 in Warsaw, Poland, and immigrated to Canada in 1977. He now works in New York. His public projections have been staged throughout the world and he has been part of numerous important group exhibitions, including Dokumenta 6 (Kassel, 1977), the Sydney Biennale in 1979 and 1982, 'Aurora Borealis' In Montréal (1985), and the Venice Biennale in 1986.

INDEX

Adrian, Robert: *Great Moments in Modern Art II (Joseph Beuys Crashes in Russia, 1943)*, 11–12
Alexander, Lawrence, 76–7
Althusser, Louis, 116
April, Raymonde, 41
Arendt, Hannah, 91
Arp, Hans, 70
Ayearst, Sheila, 11, 135; *Approaching Giorgione*, 8; *Fin de Jour*, 8; *Living on the Edge*, 9; *Sensible Passage*, 8; *There is No Safety*, 9; *Three Minutes*, 1–4, *2*, 6, 7–8, 13, 19, 125

Balser, Michael, 118
Barber, Bruce, 117, 119, 121, 129, 135; *Nam II*, 93–6, *94*; *Remembering Vietnam Triptych*, 93
Barthes, Roland, 54, 83, 84, 111, 118, 121
Baudelaire, Charles, 24
Baudrillard, Jean, 15, 16, 116
Beam, Carl, 135–6; *The North American Iceberg, 80*, 81; *Erase*, 81
Beckmann, Max, 27
Bélanger, Sylvie, 136; *Essai de Synthèse*, 64–7, *65*; *Triptych*, 67
Benjamin, Walter, 1, 48–9, 115, 120
Beuys, Joseph, 12
Bierk, David: *Save the Planet/Autumn Sunset to Keith and Caravaggio*, 12
Boethius, 47
Boltanski, Christian, 55
Borges, Jorge Luis, 11
Boyle, Sonia, 41
Bryson, Norman, 45
Bürger, Peter, 20
Burgin, Victor, 111
Burnett, David, 22
Burnett, David, and Marilyn Schiff, 20, 113
Buyers, Jane, 112, 136; *Language/ Possession* 81, *82*, 83–4

Cahn, Miriam, 41
Caravaggio, Michelangelo Merisa da; *Death of the Virgin*, 12; *Flagellation*, 127
Carr, Emily, 16
Carr-Harris, Ian, 136; *Nancy Higginson, 1949–* , 55
Cartier Bresson, 113
Casey, Edward S., 61, 67, 96
Chambers, Jack: *The Hart of London*, 55; *Madrid Window No. 2*, 12
Charney, Melvin, 136; *Better if They Think They are Going to a Farm . . .*, 88; *Les Maisons de la rue Sherbrooke*, 81, 86–8, *87*
Chipp, Herschel B., 42
Clay, Allyson, 11, 29–30, 32, 137; *Constellation of the Great Owl*, 30; *Cross by the Sea*, 30; *Lure*, 30, *31*, 32, 34, 36, 44, 83, 93, 117; *Paintings with Voices*, 34
Clemente, Francesco, 41
Cohen, Sorel: *Re-reading two Empires*, 12
Condé, Carole, and Karl Beveridge, 111, 137; *No Immediate Threat*, 123, *124*
Constructivism, 16, 18, 19
Corridart Exhibition, 81, 86
Cran, Chris, 11; *Self-Portrait as Max Beckmann*, 27, 117
Cubism, 16–18

Dada, 70
David, Jacques Louis: *Madame Récamier*, 12; *Oath of the Horatii*, 60–1
de Bolla, Peter, 63
Degas, Edgar, 12
Deitcher, David, 24
Delaunay, Robert, 32
Denniston, Stan, 137; *Dealey Plaza/ Recognition and Mnemonic*, 100; *Kent State U./Pilgrimage and Mnemonic*, 96–8, 100; *Reminder #20*, 98–100, *99*
Derrida, Jacques, 39, 73, 97, 111
Doesburg, Theo Van, 22
Douglas, Stan, 125

Duras, Marguerite, 56

Eagleton, Terry, 6, 100
Eco, Umberto, 111, 127
Evergon, 111, 127, 137
Ewen, Paterson, 64

Fabo, Andy, 11, 127, 138; *The Craft of the Contaminated*, 13, 14, 15–16, 18, 117; *Laocoön Revisited*, 118; *Medicine Man Memory*, 16; *Survival of the Delirious*, 118
Fafard, Joe, 11, 138; *Gauguin*, 26; *My Art Critic*, 27; *Vincent*, 24, *25*, 26–7
Fastwürms, 138; *Father Brébeuf's Fugue State*, 81
Favro, Murray, 11, 138; *Van Gogh's Room*, 24, 26, 27, *28*, 29, 55, 83
Fenton, Terry, and Karen Wilkin, 22
Ferguson, Bruce, 54–5
Ferguson, Bruce, and Sandy Nairne, 41
Fleming, Marie, 29
Fokkema, Douwe, ix
Foster, Hal, 123
Foucault, Michel, 19, 70–1, 101, 119
Fragonard, Jean-Honoré, 9
Fried, Michael, 24, 26
Freud, Sigmund, 41, 58–9

Gale, Peggy, 55
Gasse, Jocelyn: *Composition No. 104*, 64
Gauguin, Paul, 21
Geleynse, Wyn, 61, 138; *Fear of Memory*, 52–4, *53*, 79; *Portrait of My Father*, 54; *Remembering*, 54, 58; *We Never Knew Her Past, Than Through Her Photos*, 54
Geltner, Gail: *Closed System*, 12
General Idea, 11, 138–9; *1984 Miss General Idea Pavilion*, 4; *1984 Miss General Ideal Pageant*, 125; *Snow Bird*, 12; *The Unveiling of the Cornucopia*, 1, 4–6, *5*, 7, 13, 15, 43, 48, 67, 77, 114
Géricault, Théodore: *The Raft of the Medusa*, 13, 15–16, 19
Giorgione: *Tempest*, 8
Gogh, Vincent van, 20, 24, 27
Goodman, Nelson, 1
Gormley, Antony, 41
Gosselin, Marcel, 139; *Delta* exhibition, 51, 52; *Fragments* exhibition, 51–2; *The*

Observatory, 49–51, *50*
Goya, Francisco de: *Colossus*, 9
Grauerholz, Angela, 139; *Basel*, 58, 61–4, *62*; *Clouds*, 64; *Landscape*, 64; *Mountain*, 64
Greenberg, Clement, 21, 27
Group of Seven, 12, 15, 117
Gurney, Janice, 139; *The Damage is Done*, 74, 75–7, 81, 93, 95; *1001 Details from 'Genre'*, 75; *Portrait of Me as My Grandmother's Faults*, 75; *Screen*, 56–8, *57*, 60, 75–6, 81, 93, 119

Haacke, Hans, 95; *U.S. Isolation Box, Grenada, 1983*, 93
Harris, Lawren, 15, 117
Hassan, Jamelie, 139; *Los Desparecidos*, 92–3; *Primer for War*, 93
Heartfield, John, 95–6, 120
Hogarth, William: *The Four Stages of Cruelty*, 47
Holbein, Hans: *The Ambassadors*, 45, 47
Hume, Vern, 139–40; *Lamented Moments/ Desired Objects*, 67–70, *68*
Hutcheon, Linda, xi, xii, xiii, 8, 16, 71

Ingres, Jean-Auguste-Dominique, 12

Jameson, Fredric, 6–8, 9–10, 100, 116–7
Johns, Jasper: *In the Studio*, 19
Joosten, J., and Robert Welsh, 34
Judd, Donald, 12

Kandinsky, Wassily, 23, 32
Kaplan, E. Ann, 100
Kelly, Mary, 42, 43–4, 45
Kiefer, Anselm, 11
Klee, Paul: *Angelus Novus*, 48–9
Klein, Astrid, 41
Koop, Wanda: *Airplane*, 64
Kraus, Rosalind, 114
Kuhn, Annette, 121
Kundera, Milan, 100
Kupka, Frantisek, 32
Kuspit, Donald, 21

Lacan, Jacques, 45, 47
Lawlor, Michael, 120
LeDuc, Ozias: *Fin de Jour*, 8

Levine, Sheri, 11
Lowenthal, David, 7
Ludlow, Greg, 11, 140: *All Conditions Are Temporary*, 16–19, *17*
Lukacs, Attila Richard: *Junge Spartaner Fordern Knaben zum Kampf Heraus*, 12
Lyotard, Jean-François, 63, 111

McConathy, Dale, 86
McDonnell, William, 140; *22 July 1968/16 November 1885*, 81, 84–6, *85*
Malevich, Kasimir, 22, 32
Manet, Edouard, 24
Marinetti, F.T., 42
Marsan, Jean-Claude, Lucie Ruelland, and Pierre Richard: *Mémoire de la rue*, 88
Mays, John Bentley, 48
Miles, Geoff, 11, 112, 140; *Foreign Relations, 110*; *The Trapper's Pleasure of the Text, 112*
Modernism, 11, 13, 19–27, 32, 34–6
Molinari, Guido, 19, 20, 21–3, 26, 140–1
Mondrian, Piet, 19, 21, 22–4, 26, 32–4, 41
Monk, Philip, 20
Mycroft, Robert, 128

Newman, Avis, 41
Newman, Barnett, 42
Nemiroff, Diana, 86
Neoplasticism, 21, 33

Painters Eleven, 13
Patton, Andy, 75
Pek, Robin, 12
Picasso, Pablo, 19; *Demoiselles d'Avignon*, 18
Piero della Francesca: *Flagellation of Christ*, 8
Plato, 39, 61, 70
Poitras, Ed, 81
Pollock, Griselda, 45
Pontbriand, Chantal, 63
Preziosi, Donald, 41

Rembrandt, 3, 8, 19: *Anatomy Lesson of Dr. Joan Deijman*, 1, 125
Repentigny (Jauran), Rodolphe de, 22
Rank, Otto, 60

Schafer, R. Murray, 120
Scott, Nigel, 121, 141; *Maillot Noir et Blanc*, 121, *122*
Sherman, Cindy, 55
Sherman, Tom, 141; *Exclusive Memory*, 55
Simone Martini, 113; *Guidoriccio da Fogliano*, 83–4
Smith, Paul, 71, 77
Smolik, Noemi, 55
Snow, Michael: *Plus Tard*, 12
Sontag, Susan, 121
Steinman, Barbara, 55, 93, 141; *Borrowed Scenery*, 92; *Cenotaph, 90*, 91–2
Sterbek, Jana, 41
Stimpson, Catharine, 115
Sweeny, James, 22

Teitelbaum, Matthew, and Peter White, 26
Terdiman, Richard, 7
Teuber-Arp, Sophie, 22
Théberge, Pierre, 22
Thomas, David: *Lecture to an Academy*, 12
Tickner, Lisa, 116

Tod, Joanne, 11, 29–30, 127–9, 141; *Allegro Furioso Ma Sterotypissimo*, 127; *Approximation*, 39, *40*, 42–5; *Identification/Defacement*, 42; *Magic at Sao Paulo*, 42; *My Father, Bob and I*, 42; *Reds on Green*, 34–6, *35*, 44; *Self Portrait*, 42, 125; *Self Portrait as Prostitute*, 42, 125, *126*; *The Upper Room*, 75, 76
Tousignant, Claude, 11, 23, 26, 141; *Hommage à Van Gogh*, 19–22, 24, 27, 34, 36
Turner, J.M.W., 64

Vattimo, 111
Virilio, Paul, 66
vom Bruch, Klaus, 41
von Stroheim, Erich, 58

Wainio, Carol: *The Sight (Site) of a Memory Trace*, 12
Wall, Jeff: *The Storyteller*, 12, 121
Wallace, Ian, 12, 32
Warnock, Mary, 73

Wedman, Neil, 142; *Death Ray*, 45–9, *46*;
　Margery, 49
Whittome, Irene F.: *Le Musée de Traces*, 52
Wieland, Joyce, 111; *Notice Board*, 13;
　Redgasm, 13
Wiens, Robert, 142; *Before the Rising
　Spectre*, 79; *Bush T.V.*, 79; *The Rip*, 77–
　81, *78*, 98

Wittgenstein, Ludwig, 4, 11
Wodiczko, Krzysztof, 83, 88–91, 142;
　Courthouse Projection, 91

Yates, Frances, 84

Zoffany, Johan, 12
Zurburán, Francisco de, 12